Photography
REBORN
IMAGE MAKING IN THE DIGITAL ERA

Jonathan Lipkin

ABRAMS STUDIO

HARRY N. ABRAMS, INC., PUBLISHERS

For Danae, Sophia, and Eve

Project Manager: Céline Moulard
Designer: Eric Janssen Strohl, Eric Baker Design Associates
Production Manager: Norman Watkins

Library of Congress Cataloging-in-Publication Data
Lipkin, Jonathan.
Photography reborn / Jonathan Lipkin.
 p. cm.
Includes bibliographical references and index.
ISBN 0–8109–9244–2 (pbk.)
 1. Photography—Digital techniques. I. Title.

TR267.L57 2005
775—dc22

 2004028167

Printed and bound in China
10 9 8 7 6 5 4 3 2 1

Harry N. Abrams, Inc.
100 Fifth Avenue
New York, N.Y. 10011
www.abramsbooks.com

Abrams is a subsidiary of

CONTENTS

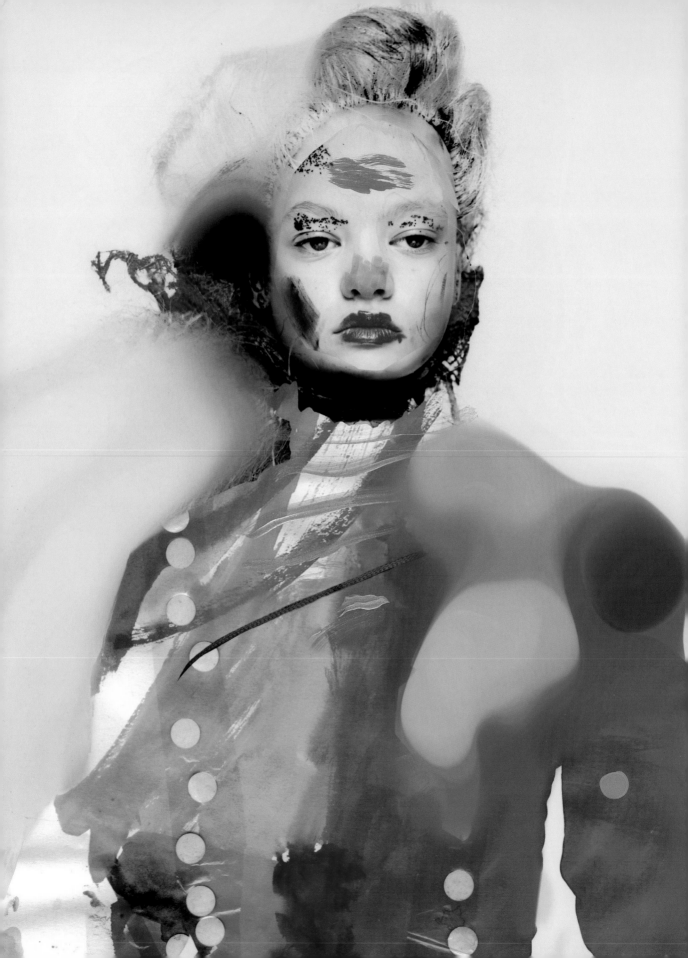

INTRODUCTION

Since its birth one hundred and fifty years ago, photography has become such an integral part of our culture that it is hard to imagine life without it. Photographs have been used by artists for visual expression, by journalists to record events, by scientists to gather data about the physical universe, and by nearly everyone else drawn by photography's ability to faithfully record the world, its low cost, and its ease of use. So it stands to reason that any change in photography will have a significant effect on the way we live our lives, the way we remember the past, the way we understand the world.

NICK KNIGHT. *DOLLS*, FOR SHOWstudio.com. DIGITAL PHOTOGRAPH, 1999. Courtesy the artist.

ANDREAS GURSKY. *ATLANTA*, 1996. C-PRINT, 73¼ X 102⅜ INCHES. Courtesy Matthew Marks Gallery, New York. © 2005 Andreas Gursky/ Artists Rights Society (ARS), New York/VG Bild-Kunst, Bonn.

In many of his photographs, Gursky disputes the one-point perspective imposed by the lens. This image consists of at least two photographs joined seamlessly. It depicts a place, but in a manner that breaks with the five-hundred-year tradition of perspective. By making such an obvious change in the image, Gursky hints at the subtler changes he may have made to the image and to the instability of the photographic act. Not willing to define himself as a "digital photographer," Gursky is one of a number of artists who see digital tools and techniques as a part of the photographer's repertoire today.

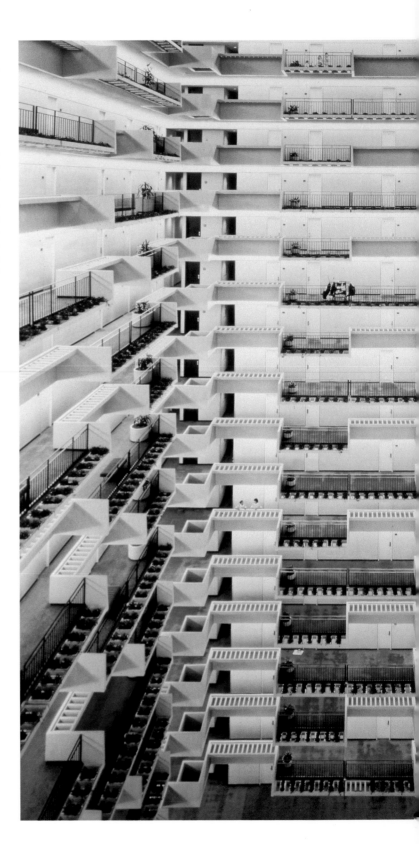

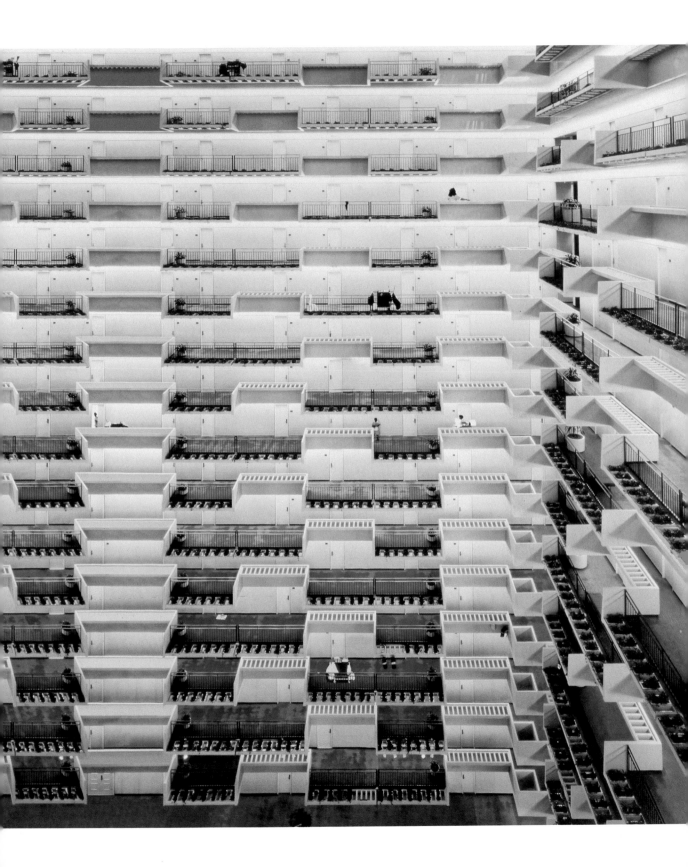

Digital photography stands poised to replace its film-based predecessor: in 2003, for the first time, the sales of digital cameras in the United States exceeded those of film cameras. Throughout the 1980s and early 1990s, artists, scientists, and photographers used high-end computer systems not available to the general public to create digital images. By the end of the 1990s, sophisticated photo-manipulation software and the hardware to run it—not to mention desktop printers that rivaled the accuracy and resolution of traditional photographic darkrooms and a vast electronic network that allowed almost anyone to transmit a photograph instantaneously to anyone else—had become available to a mass audience, often bundled with inexpensive digital cameras.

As photography moves from the realm of the physical into the realm of the circuit, as photographs become nothing more than strings of numbers, the medium itself is transformed. This change represents more than just another stage in photography's evolution. Digital photography is photography reborn. Thanks to digital technology, the boundaries of the photographic act, once quite clear, are now shifting in unexpected and unrecognizable ways. Some digital photographic images—those created with digital cameras—are very clearly descended from their traditional forebears. Others share a different lineage, however much they may look like photographs: they are drawn, or "rendered," in a computer and in spite of their outward appearance have more in common with paintings. This is a radical departure from lens- and film-based photography, which can produce only a likeness of something that has a physical existence. Digital photography makes possible every conceivable variation and combination of these different sorts of images. In the nineteenth century, Ada Lovelace described an early mechanical computer as weaving algebraic patterns like a loom; today we might say that computers weave photographs out of electrons.

How can we define digital photography? Traditional views of photography do not seem to encompass it. In 1966, in *The Photographer's Eye*, John Szarkowski enumerated the elements "peculiar to photography": "The Thing Itself," "The Detail," "The Frame," "Time," and "Vantage Point." Today, digital technology has radically transformed each of these. In "The Thing Itself," Szarkowski remarks that "our faith in the truth of a photograph rests on our belief that the lens is impartial," while in "The Detail," he describes photography as essentially different from painting, since once captured, the contents of a photograph are difficult to alter. Both of these statements are called into question by image-rendering and photo-manipulation software. In "The Frame," Szarkowski describes photography as a reductive act, one that forces the photographer to make choices about what to include in the frame of the photograph. But digital tools allow the photographer to supplement that choice, to add elements that were outside the initial frame of the image—or to erase elements from it. "Time" and "Vantage Point" are infinitely malleable in a digital environment, as digital cameras can be used to collect data over months or even years, visual data that can be used to synthesize photographic images from any one of a multitude of perspectives. Note how irrelevant to digital photography is Henri Cartier-Bresson's still-popular notion that the proper task of the photographer is to capture the "decisive moment," releasing the shutter when all the elements of a photograph come together. Digital images are in many ways like traditional still lifes. In a still life, a photographer or painter collects subjects that are of interest, and photographs them in a studio. In digital images, the photographer

collects subjects by photographing them. In place of the studio, the photographer brings the images together through image-manipulation software.

One of the most revolutionary properties of photography, its status as the first imaging technology where an image is taken directly from the visible world, is attributable to the passive, mechanical way that light acts on the film in the camera. The relation between a photograph and the scene it portrays has been called indexical—a term invented by the American philosopher Charles Sanders Peirce to designate a direct relationship between a signal carrying a sign and the sign's object, as smoke is a signal for fire—because of the one-to-one correspondence between the two. A photograph is a sign carried by the light reflected off the objects it represents. The French critic Roland Barthes once wrote that "the referent adheres" to the photograph.

However, the intervention of electronic technology has severed the tie between the photograph and the world. As the artist David Hockney says, "Computer manipulation means that it's no longer possible to believe that a photograph represents a specific object in a specific place at a specific time— to believe that it is objective and 'true.'" The special, even legal, position that photography once had is gone. The hand has returned to lens-based images, as the computer has brought the photograph closer to drawing and painting once again. Its software uses terms like "palette," "brush," "pencil," and "paintbox."

The digital photograph, so easily manipulated, can no longer be trusted to accurately represent a scene. It is not even strictly indexical, in Peirce's sense of the word. Artists are using digital photography to make us acutely uncomfortable about equating photographs with reality. Confronted by a fabricated image that looks like a photograph, we may understand, intellectually, that it is a fiction, but our expectation that a photograph reveals something "real" produces a disturbing feeling of dissonance. This expectation will certainly change as a generation grows up with digital cameras and software that allow such easy manipulation of the photographs they create.

Of course, a digital photograph need not be any less faithful to physical reality than a traditional photograph. The image is determined by a set of data, but we must remember that this data—unlike light—is only sometimes representative of physical reality. In the case of the Magellan space probe, which orbited the planet Venus between 1989 and 1994 bouncing radar off the surface of the planet, the data collected were based on physical reality, and were compiled into a detailed topographical map of the planet's surface (see p. 20). Using a technique called ray tracing, which traces imaginary rays off a virtual object, scientists were able to "photograph" this map in the virtual space of a computer, simulating photographs that might have been taken by a camera positioned on the planet's surface. However, the same technique is more often used to generate pictures of imaginary objects created in 3-D modeling and animation programs, such as those used to create the films *Shrek* or *Toy Story*. In both cases, the resulting image is constructed by "real" data, but in the latter example the image does not have any relation at all to an object in the physical world, only to the algorithms of the computer and the imagination of the artist.

In this book, I hope to show that recent changes in photography cannot be understood by technological advances alone. The radical changes in painting that occurred over the past two hundred years had very little to do with the technology of applying paint to canvas. The modernism of the early twentieth

century offered a radical new way of looking at a world that was shaped by a host of social, cultural, and technological innovations, not the least of which was photography. Yet the canvases of Pablo Picasso and Henri Matisse were not, by and large, produced through any new technology; their shocking newness reflected more profoundly a shift in thought and feeling, a shift of attitude.

Digital photography is at once a new attitude and a new technology. It is even possible that the attitude came first: the look and content of digital photographs today—in both the arts and sciences—was prefigured by analog work of the 1960s and 1970s. Like traditional photography before it, digital photography's impact is largely due to the process through which it makes images: it is first experienced as a new technology. What is so radically transforming about digital photography, however, is not the technology itself, but the ideas that ultimately are expressed by it. Perhaps for this reason, many of the artists in this book do not identify themselves as digital artists or digital photographers, only as photographers or artists, indicating that for them, digital tools have simply become a part of the photographic canon.

Perhaps the best way to characterize digital photography, or any digital technology for that matter, is that it dissolves boundaries that once separated mediums. Digital photography sprang from traditional photography, and the names of early photo-manipulation software—Digital Darkroom, Photoshop— are testament to the fact that people thought of them as a supplement to traditional tools. But it quickly became clear that electronic digital technology was not as stable as the mechanical technology that produced photography in the nineteenth century. Technology today does not evolve in a clear linear pattern. It shifts and mutates in great leaps and bounds, and often in unexpected directions. Because of this, the future holds more questions than answers. What will happen as digital cameras surpass the quality of the best film cameras, or when they become small enough to fit into our eyeglasses—or our retinas? What happens when digital cameras become directly connected to distribution networks and photographs can be shared instantly (this is already happening with cellular phones that have cameras integrated into them)? How will these advances change our notion of what photography can or should be? What will happen as modeling software becomes increasingly capable of generating photo-realistic imagery that cannot be distinguished in any way from real life? The only thing we can be sure of is that the human desire to understand the world through representation will propel the process of making images through greater and greater changes in the years to come.

SIMEN JOHAN. *UNTITLED #118*, 2003. C-PRINT. 44 X 44 INCHES. Courtesy the artist and Yossi Milo Gallery, New York.

What Is DIGITAL Photography?

The most important thing to understand about digital photography, or any digital technology for that matter, is that it uses information as its raw material. Traditional analog photography is a process of creating and manipulating objects, while a digital photograph is a complicated set of relationships among reality, data derived from that reality, and the electronic processes of a computer. In traditional photography, a piece of film in a camera is exposed to light, then developed to produce a negative, which in turn is used to produce a print. In digital photography, a camera or other device is used to create a set of numbers stored in a computer—a file—that in turn can be displayed on a screen or used to create a print. In effect, the digital file is the "negative" in the process—the original used to create copies. Digital photography is a process of creating, storing, and manipulating numbers in a computer, and then rendering them into visual images.

MARGI GEERLINKS. *UNTITLED (GIRL KNITTING BABY)*, 1997–98. FUJIFLEX, PLEXIGLAS AND REYNOBOND, 67 X 49¼ INCHES. Courtesy Torch Gallery, Amsterdam.

CRAIG KALPAKJIAN. *MONITOR*. 1998. CIBACHROME PRINT MOUNTED ON ALUMINUM. 38 X 46 INCHES. Courtesy the artist and Andrea Rosen Gallery, New York.

Kalpakjian uses 3-D software to create images that resemble photographs in their outward appearance, and yet have no referent—they are fabricated out of no more than the algorithms of the computer. *Monitor* shows a ceiling-mounted dome, presumably housing a surveillance camera. The absence of a reflection in the dome where a photographer should be reminds us that the image is computer-generated. That it reflects an open door perhaps suggests the potential of the digital medium.

A digital photograph is encoded in the computer and then output to a screen or a printer as a bitmap (literally a "map of bits"): a grid, whose squares are called "pixels," with a set of binary digits (called "bits") assigned to each pixel. Where a traditional photograph contains silver halide crystals or dye that create color and tone, a bitmap contains only zeros and ones. This bitmap converts the "continuous tones" that we experience in normal vision, where colors blend imperceptibly into one another, into discrete gradations of tone.

Like any map, a bitmap can contain more, or less, information. The greater the number of pixels in a bitmap, the finer the resolution of the image, and the greater detail it will have, since it can provide more information to an output device. If the size of these pixels falls below the threshold of human vision, the image appears to have continuous tone. If not, the pixels themselves become visible, in which case we say that the image is pixelated or bitmapped. For most viewers, this occurs when there are fewer than fifty pixels per inch.

Just as the number of pixels in a bitmap determines the resolution of the image, the amount of information assigned to each pixel determines its "depth." This somewhat confusing term refers to the number of bits that are available to describe each pixel of the image. A greater number of bits assigned

HENRIK WANN JENSEN. Courtesy the artist.

Image produced by BSSRDF shading model software. 3-D modeling software creates digital images by bouncing virtual light off the surface of virtual objects. Some surfaces are easy to model because they interact with light in a very simple way. Human skin, though, is particularly hard to render, since it is partially transparent (simply looking at a fair-skinned person confirms this, as veins and arteries are visible beneath the surface). Henrik Wann Jensen at Stanford University has written software that simulates the way light scatters below the surface of an object, and so is capable of producing remarkable images that are nearly indistinguishable from traditional photographs. Rendering software is highly computer-intensive, and Jensen's software would not have been possible with the computers from only a few years ago. As computer speeds increase, and as new rendering software is written, the quality of rendered digital images will equal, and eventually surpass, those created by traditional photography.

to each pixel multiplies the number of colors the image can have. A one-bit image—that is, an image in which each pixel can be described by only one bit, a zero or a one—has enough information to represent a two-color image. A twenty-four-bit image, one that assigns twenty-four bits of information to each pixel, can describe more than sixteen million colors and is the most common bit depth for digital images today. As the width, height, and depth of an image increase, the computational resources required to process the image increase in an exponential fashion.

There are several ways to create an image by filling in a bitmap's grid. Perhaps the most familiar of these is to use a digital camera, because of its similarity to traditional photography. Cameras, however, are not the only way to create a digital image that appears to be photographic. Scanners that convert traditional photographs into bitmaps are now ubiquitous; once digitized, a photograph becomes infinitely malleable. Since bitmaps are composed of numbers, however, any computational process capable of generating a set of numbers can theoretically create a digital image that resembles a photograph. For example, bitmaps generated by 2-D digital paint programs and 3-D modeling software

COMPOSITE MRI OF THE HUMAN BRAIN. Courtesy DA Silbersweig and Cornell University Medical College.

Photography is, in essence, the art of capturing time, of fossilizing a short moment so that it can be contemplated later. Photographs can freeze an instant, showing us the splash of a drop of milk, or can describe a slightly longer period of time, as seen in a blur of motion. Recent developments in digital technology have provided scientists with the ability to visually examine events on scales of time never before possible, and even glimpse events that are only abstract representations of statistical data. This image was produced using data collected from a series of MRI scans, which can detect minuscule changes in blood flowing through the brain. Since blood flow is thought to correlate with mental activity, scientists believe they can detect which areas of the brain are used for specific tasks. This data can be used to construct images of single events, but it can also be analyzed and processed to produce images of many events—pictures of statistical analysis. This particular image shows the results of an experiment that tries to pinpoint the location of emotions in the brain. Subjects listened to neutral words ("accompany," for example) and depressed words ("incompetent") as their brains were being scanned. By subtracting the data from the neutral word scans from that of the depressed word scans, scientists hoped to eliminate the areas of the brain that processed language, leaving only those that responded to the emotional content of the words. What we see here has as much in common with a graph (which can be used to visually examine data) as it does with a traditional photograph.

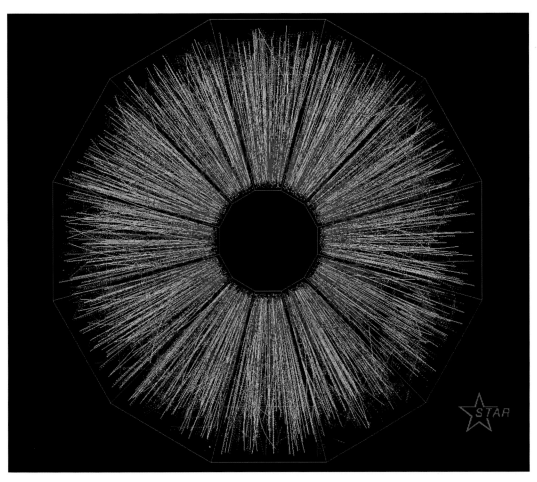

END VIEW OF THE COLLISION OF TWO 30-BILLION ELECTRON-VOLT GOLD BEAMS IN THE STAR DETECTOR AT THE BROOKHAVEN NATIONAL LABORATORY.
Image reproduced by permission of Brookhaven National Laboratory, STAR experiment.

This image was produced by scientists interested in observing the behavior of subatomic particles. The Relativistic Heavy Ion Collider at the Brookhaven National Laboratory accelerates atoms to nearly the speed of light, and smashes them together, where they briefly reach a temperature of one hundred thousand times the sun's core. The STAR detector is one of the experiments on the RHIC set up to detect subatomic particles released by these collisions. Each ring uses 1,740 superconducting magnets to accelerate gold ions, atoms of the atomic element gold that have been stripped of their electrons. Where the rings intersect, the ions collide and their kinetic energy is converted into matter in the form of subatomic particles. A traditional photograph would not be able to capture the collision: the particles are too small and fast, so scientists built a grid of wires around the collision site. As the particles travel away from the collision, they cause a measurable electric charge to form in the wires, which is then recorded and stored in the detector's computer. This data was used to create the image reproduced here.

often produce photo-realistic images. Using these and other computer programs, artists can alter photographic images for expressive purposes far beyond what was possible with analog tools.

Meanwhile, scientists have been using digital imaging technology to observe things they would not ordinarily be able to see with the naked eye or a camera. Digital imaging techniques can peer inside the human body, "see" wavelengths of light outside the visible spectrum, and create images that demonstrate the validity of experiments by aggregating statistical data. Each of these types of images expands our notion of what a "photograph" can be.

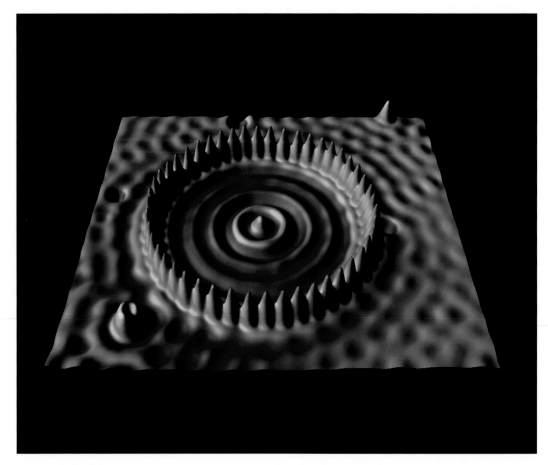

IBM ALMADEN RESEARCH LAB, *QUANTUM CORRAL.* Image reproduced by permission of IBM Research, Almaden Research Center.

Digital imaging techniques allow scientists to visually examine things that were once invisible to the naked eye, from the very far to the very near. Scientists at IBM's Almaden Laboratory produced the startling image above of an electron trapped in a "corral" of iron atoms using a scanning tunneling microscope (STM). An STM creates an image by passing a probe over the surface of an object and creating a topographical map, a set of numbers that describe the height of the surface at any particular point. This data can be used to make a digital image, one whose colors are "false" because they are not formed by light but instead represent some characteristic of the image, in this case height. Note that the colors go from cool to warm, from blue to red, as the height of each bump in the corral increases. A ring of iron atoms had been created by an electrical charge run through the tip of the probe, essentially running the STM in reverse, depositing atoms on the surface, which was then scanned by the STM to generate the data that in turn generated the image. This "corral" of iron atoms trapped an electron within its confines, catching it in a standing wave. The image at right was produced by the Wide Field Planetary Camera (WFPC2) aboard NASA's Hubble telescope. It is a composite of three separate images calibrated to the wavelengths of different gases: nitrogen, hydrogen, and doubly ionized oxygen—red, green, and blue, respectively. The WFPC2 uses four charge-coupled devices (CCDs) to capture images in digital form, which can then be sent from the satellite to scientists on Earth. Because of their clarity and resolution, Hubble's images have given scientists new insight into the Hourglass (MyCn13) nebula, the clouds of gas surrounding a dying star.

HUBBLE SPACE TELESCOPE IMAGE OF THE HOURGLASS NEBULA. January 16, 1996, photographed by R. Sahai, J. Trauger, the Wide Field Planetary Camera 2 team, Jet Propulsion Laboratory, and NASA. Courtesy NASA and STScI.

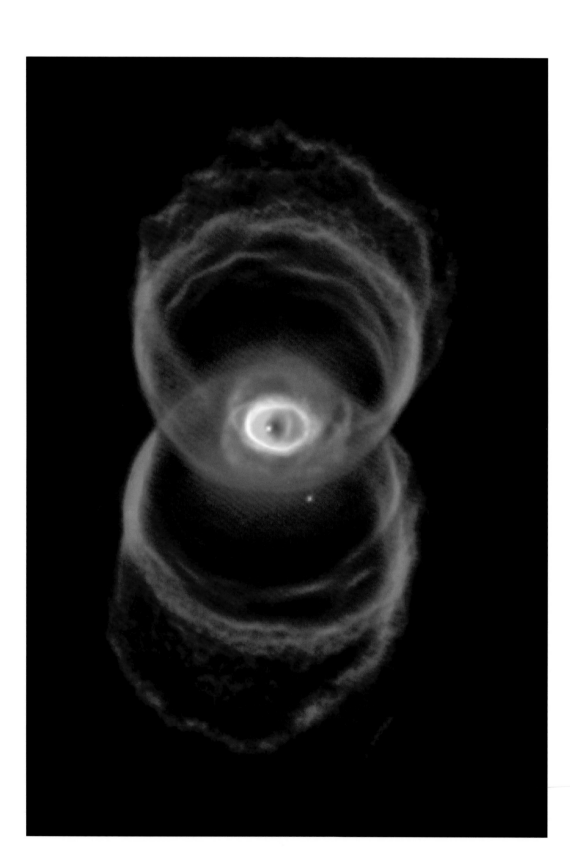

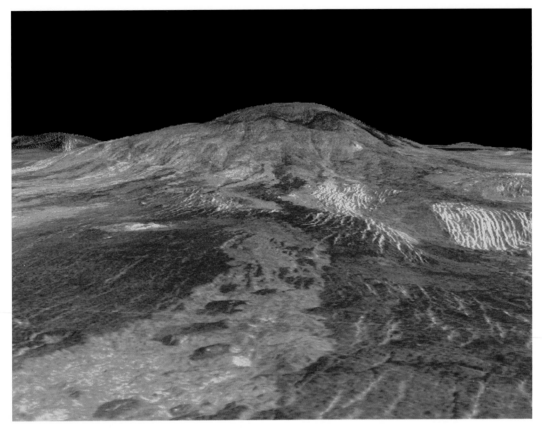

3-D PERSPECTIVE OF OVDA REGIO, VENUS, 1993. Courtesy NASA/JPL-Caltech.

Plausible computer-simulated views of the surface of Venus, like this one of Ovda Regio, have been created from data collected by the Magellan satellite, which orbited the planet from 1989 until 1994. They begin with elevation data in digital form, called a DEM (Digital Elevation Model), acquired by bouncing radar off the planet's surface. The image itself is fabricated by a ray-tracing program, whose principles are based on optical systems, whose origins lie in Renaissance Europe and medieval Islam. The computer program positions a "virtual camera" in a "virtual space," then draws the image-based light from an imaginary light source. This image is accurate to 75 meters, which is very good for a simulation based on satellite radar data. The image was produced at the JPL Multimission Image Processing Laboratory by Eric De Jong, Jeff Hall, and Myche McAuley.

FROM THE DARKROOM TO THE DIMROOM

Digital photography has altered the photographer's creative process at every stage. The most salient change, perhaps, is the photographer's ability to make editing decisions about a body of work instantly, without having to develop film and make prints. When a digital camera takes a photograph, a liquid crystal display (LCD) shows the actual digital image created by the camera; instead of looking through the viewfinder of a traditional camera, photographers today can look at the image itself as it is being formed. Photographers can review photographs that they have already taken by using this same screen, reflect on what they have done, and throw out those images they don't need or want: there is no need to travel to the darkroom or wait for processing.

Computer programs are used to manipulate images once they have been created by a digital camera. Where printing a traditional photograph involves making changes to a physical object, working on a

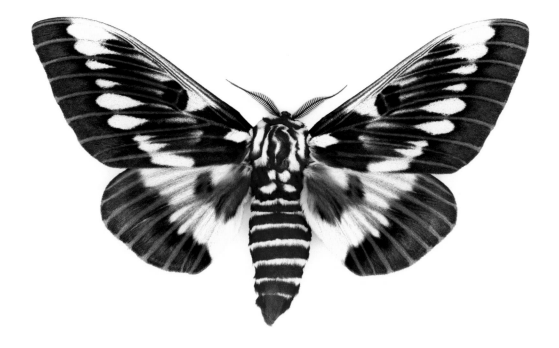

JOSEPH SCHEER. *CITHERONIA SPLENDENS*, 2004. IRIS PRINT ON ARCHES WATERCOLOR PAPER, 34 X 46 INCHES. Courtesy the artist.

Flatbed scanners are designed to digitize—that is, convert to digital form—photographs and prints in much the same way that a photocopier makes copies: they use a sensor to read light reflected off the photograph. Like Susan Silton (see p. 42), Joseph Scheer places objects—in this case, moths—on the platen of the scanner to produce the high-resolution scans used to create the image shown here. His work on moths began serendipitously when, looking for a way to test a newly installed scanner, he caught a gnat buzzing around an office plant and placed it on the scanner. He was astounded by the resulting image. The scanner revealed unexpected details in the insect: tiny hairs covering the body, "pearlescent wings." Like any photographer, Scheer was excited by the possibility of using a newfound technology to reexamine through imagery what might otherwise seem pedestrian or everyday. He began collecting and scanning moths. He had previously gathered dead moths from his studio, collecting them on a plate on his desk. Soon he approached collecting more seriously, going out each night with a net to catch insects. Within days, he had collected more than two hundred different species of moth. By the end of the summer, he had collected thousands. By printing the images on a large-format Iris printer capable of making images several feet wide, he found that moths that might seem mundane become wondrous. Divorced from their natural environments, the moths loom like prehistoric monsters, astounding us with the range of color, and in the detail, revealed by Scheer's scans.

"Can something as basic as the image of a common moth reveal things we know or do not quite know about our current culture or ourselves?"

—Joseph Scheer

computer image entails using a piece of software—a program—to change the numbers that compose the photograph's bitmap. Photographers today are moving out of the darkroom into the dimroom, so called because lights are traditionally dimmed in computer labs so that users can better view the screen. The dimroom offers photographers a greater degree of control over their work than ever before, through a process that, in many ways, is easier and less toxic than traditional darkroom techniques. The most obvious feature of digital photo-manipulation is, once again, the ability to see changes instantly on the screen. As a photographer balances the contrast or color of an image, for example, the digital file is changed in real time, and the results are instant. In a traditional darkroom, a photographer would have to wait several minutes for a photographic print to emerge from the chemicals before seeing the results of a change. The speed of the computer allows the photographer

to try changes that would previously have been thought of as a waste of time, and to fine-tune the image to an extent not possible before. Furthermore, changes are inexpensive to try, since it is no longer necessary to use a sheet of paper to preview a change. Fifty different versions of an image can be created at a cost of only the photographer's time.

The available digital tools give photographers a finer range of control over their images than the techniques of chemical-based photography. In order to increase the contrast of a traditional black-and-white print, for example, the photographer would need to select a different grade of paper or use a filter, changing the tonal range of the print in a predictable manner. In the computer, the photographer has access to an input/output curve where any point from the shadows to the highlights can be selected and moved, changing the tonal values in subtle (or not so subtle) ways. In color photography, digital technology offers even more advantages, as it gives the photographer control over saturation and contrast, not to mention the ability to alter colors in isolation from one another in ways that are not possible in the traditional darkroom.

Retouching a photograph once involved painstakingly painting its surface with a pencil or airbrush. Today, the photographer can simply sample one portion of the photograph and "clone" it over another to remove blemishes. Photomontage artist John Heartfield, who created a series of images for the German magazine *AIZ* in the 1930s, often spent days working on a montage, painstakingly cutting photographs apart and gluing them back together in new configurations with hard-earned skill. Today, montage techniques such as this involve shifting pixels from one image to another, a task made so easy by software programs that a high-school student can master them in a few hours. In fact, photo-manipulation programs are a standing provocation to photographic artists to develop ever more original and imaginative ways of altering, distorting, and combining images.

Because of the way in which it is created, the tonal range of a digital photograph is different from a traditional photograph. Below a certain light level, photographic film won't register exposure, and above a certain level of exposure, no additional density can be added as the film becomes entirely opaque. A graph of the exposure density will show an S-shaped curve. As the negative begins to build exposure on one end of the scale, and as it approaches maximum density on the other, its response to light is no longer linear. Photographers have long been familiar with the problem of losing detail in the shadows and highlights due to this property of film. In a digital camera, film is replaced with a charge-coupled device, a CCD, which converts light into the zeros and ones of a digital photograph. The response of a CCD to light, however, is more or less linear. The detail in the highlights and shadows of an image is just as crisp as the midtones. As seen in Deanne Sokolin's *Covering Series #8*, this produces an image that looks entirely unfamiliar, with a tonal range unlike any traditional black-and-white photograph. With many consumer-level digital cameras, the manufacturers have chosen to create hardware that changes the input/output curve so that the digital photo more closely resembles a traditional photograph. This is nothing new: photographers in the nineteenth century would often alter their photographs to look like paintings or fine-art prints by smearing grease on the lens of their camera or using special printing processes. For all our seeming love of technology, we are surprisingly resistant to change, or at least that is what camera manufacturers seem to think.

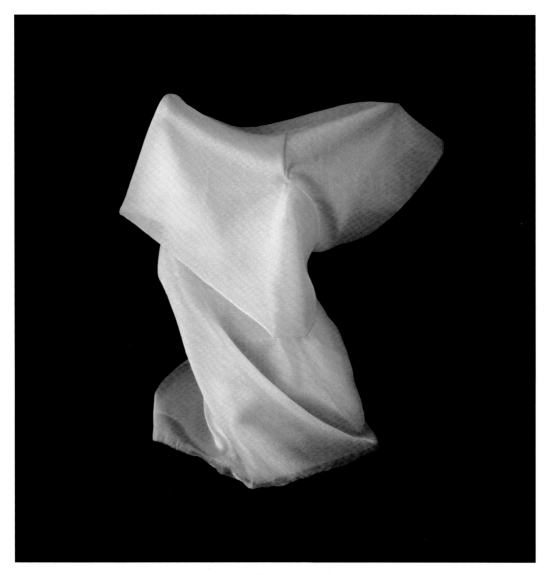

DEANNE SOKOLIN. *COVERING SERIES #8*, 1993–1996. DYE-SUBLIMATION PRINT, 12 X 12 INCHES. FROM AN EDITION OF 6. Courtesy the artist.

Deanne Sokolin covered personal objects and photographed them as a way of working through a personal loss. The Covering series references the Jewish mourning Shiva in which mirrors are covers with sheets.

DISTRIBUTION AND REPRODUCTION

The means of distributing images is essential to their role in society. Among the most popular subjects for the image-makers of the nineteenth century were Egyptian pyramids and temples, brought across newly developing rail and sea lines to a European and American public hungry for images of far-off locales. *Life* magazine, founded in 1936, owed its existence not only to new photographic and printing technologies, but also to the development of rail and trucking systems that made it economical

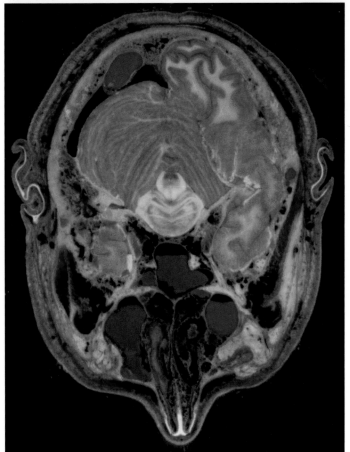

ABOVE:

Researchers at Keio University in Japan have created a technique for making 3-D models of tiny objects. Their system takes many photographs of an object that is illuminated by a narrow beam of light. The light and camera remain stationary, while the object is moved so that the portion illuminated by the light is at a constant distance from the camera. The resulting images are combined by custom-built software into the final image, which can be rotated and viewed from any side. Courtesy Kenji Kohiyama and Keio University at Shonan Fujisawa.

LEFT:

This is a digital photograph of a cross-section of a human head, made for the National Library of Medicine's Visible Human Project, launched in 1987. The project generated thousands of digital photographs taken from contiguous frozen cross-sections of a male and female cadaver, generating an enormous publicly-accessible digital image library. These photographs can be manipulated by 3-D modeling software to reconstruct any aspect of human anatomy in three dimensions, and the resulting imagery has proved enormously valuable for medical education and research, popular anatomy instruction, and even the art of anatomical illustration. Courtesy National Library of Medicine/National Institutes of Health.

to distribute the magazines once they were printed. Now, digital photographs can be sent over electronic networks at the speed of light, at virtually no cost, creating new audiences and uses. Traditional photographs are moved around in conventional ways—as an object is carried from one place to another. Digital files are "moved" through an entirely different process, that of duplication. A computer in one location sends instructions to a computer in another location to create a new file based on the original. Because digital information can be copied without error, the new file is a perfect replica of the original, much to the delight of music-sharing teenagers, and to the horror of record company executives. Transmission and duplication are one and the same for a digital photograph: sending a photograph no longer entails loss of the original for the sender, and duplication no longer entails loss of quality. As a result, the transmission and sharing of digital photographs has joined e-mail, shopping, and information retrieval as one of the most transformative and popular uses of the Internet, creating new opportunities and challenges for photographers and their agencies, copyright lawyers, news organizations, pornographers, and a host of others.

As photographs have become easier to create and distribute, as cameras have become nearly ubiquitous, the photographic act has become more casual. Early photographic plates were not very light-sensitive, and required exposures of several minutes. Subjects were often posed with head braces to prevent movement and blurred photographs. Today, photographs are easier and cheaper to create, as cameras have become just another device, part of the twenty-first century's electronic lifestyle. It is hardly surprising that in place of lighters, today's concertgoers hold up digital cameras.

In 1968, the British car manufacturer MG supplied a set of tools with its new cars. Owners were expected to change their own oil and gap their spark plugs. Today, few people even know what a spark plug is, let alone where it is in their car's engine. We are becoming increasingly ignorant of the inner workings of the technology around us. Even photography's introduction in the nineteenth century seemed to move the artist one step further from what had been until that time handwork. It would seem, superficially, that digital photography continues this tradition: the photographer is insulated from the actual "photograph" by many layers of technology. And yet, somehow, digital photography is more intimate than any previous form of photography. Images are created instantly, and once in the computer, photographs respond instantly to the photographer's touch. Earlier changes in photography, from the introduction of the dry plate to the small camera, made the creation of images easier and quicker. Digital technology has continued this trend, while subtly and profoundly changing the way we make and thus respond to photographs.

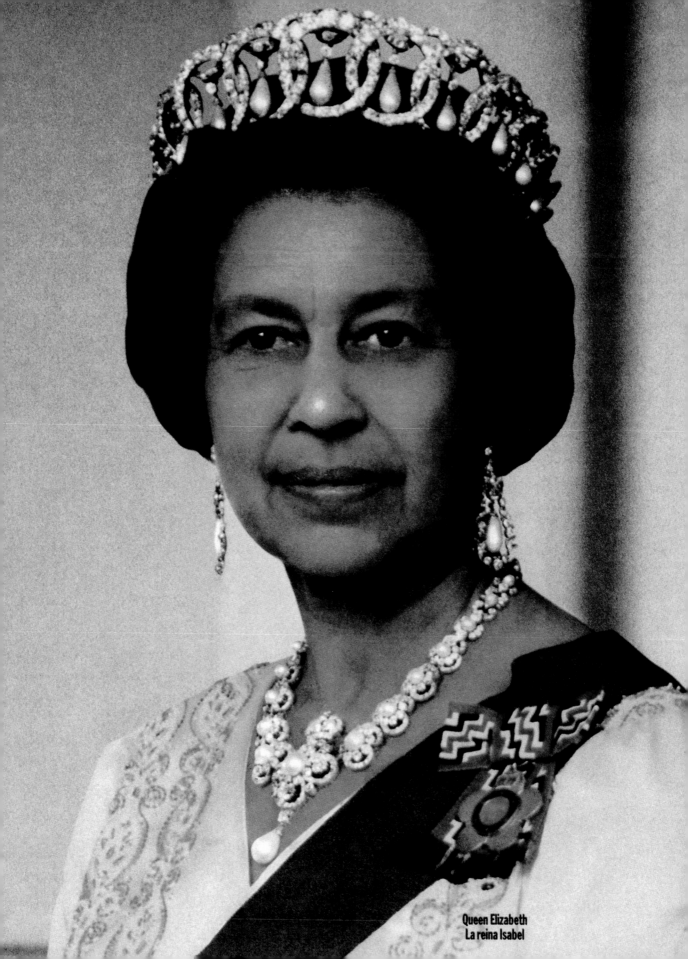

Queen Elizabeth
La reina Isabel

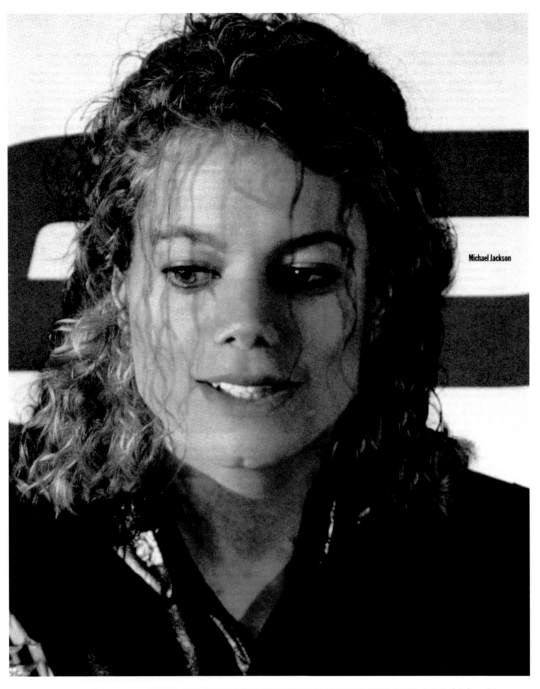

Michael Jackson

TIBOR KALMAN. *QUEEN ELIZABETH* AND *MICHAEL JACKSON*. FROM THE SERIES "WHAT IF...?," *COLORS* MAGAZINE. 4 (1993). © United Colors of Benetton. Concept, art direction: Tibor Kalman. Original photos by Ronald Woolf/Globe Photos and Steve Allen/Gamma Liaison. Retouching by Site One, New York.

Tibor Kalman's feature "what if..?", in the issue of *Colors* devoted to on the theme of race, was published at the precise moment that the public was being exposed for the first time to digitally manipulated photographs in the media. Whereas mainstream publications were using the technique to show what people had in common (see pp. 38–39), Kalman used it to raise questions about how we categorize people. His black Queen Elizabeth fascinated the British press. In the United States, the story was featured on the *Today Show*, which hired a New York graphics company to alter the appearance of correspondents at the network, showing viewers how it was done. The show's producers calculated that the audience would be as interested in the fact that photographs could now be routinely altered, as it would be by Kalman's thought-provoking visual tricks.

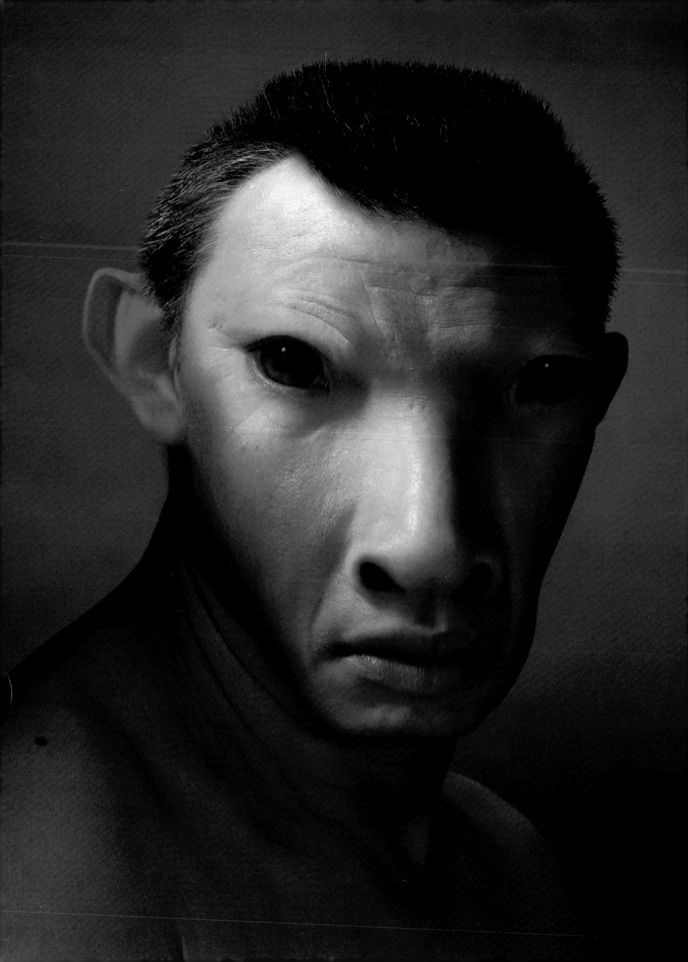

PORTRAITURE
in the Digital Age

As scientists have unraveled the complex biological mechanism that determines the inheritance of traits in living things (whose mechanism—DNA—turns out to have deep affinities to the procedures of digital computation), there has been in portraiture a commensurate turning away from the traditional emphasis on the individual and toward a means of representing physiognomic variations over time and across groups to create a new kind of portrait. Digital photography, which permits the controlled manipulation, transformation, and even merging of images, is an invitation to explore these ideas visually at a time of eroding faith in photographic portraiture as a means of revealing inner truths. In 1968, inspired by the seminal exhibition "The Machine as Seen at the End of the Mechanical Age" at New York's Museum of Modern Art, artist Nancy Burson imagined a computer-driven "age machine" that would alter a photographic portrait to make the subject appear older or younger. Burson was among the first

DANIEL LEE. *1949 - YEAR OF THE OX*, FROM THE MANIMALS SERIES, 1993. EKTACOLOR PRINT, 30 X 24 INCHES. Courtesy the artist, O.K. Harris Works of Art, New York, and Nichido Contemporary Art, Tokyo.

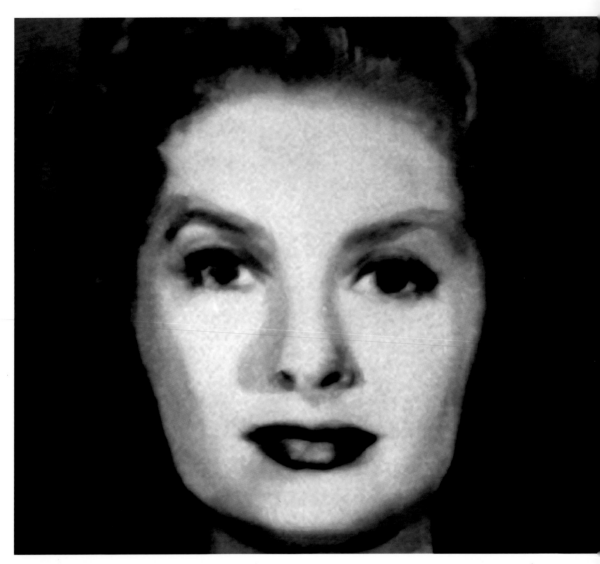

NANCY BURSON. *FIRST BEAUTY COMPOSITE (BETTE DAVIS, AUDREY HEPBURN, GRACE KELLY, SOPHIA LOREN, MARILYN MONROE)*. 1982.
COMPUTER-MANIPULATED IMAGE. Courtesy the artist.

First Beauty Composite is a combination of the great beauties of the 1950s: Bette Davis, Audrey Hepburn, Grace Kelly, Sophia Loren, and Marilyn
Monroe. *Second Beauty Composite* is a combination of Jane Fonda, Jacqueline Bisset, Diane Keaton, Brooke Shields, and Meryl Streep. These video-
graphic composite portraits attempt to capture and epitomize the differences in the ideal beauty of the 1950s and that of the 1980s.

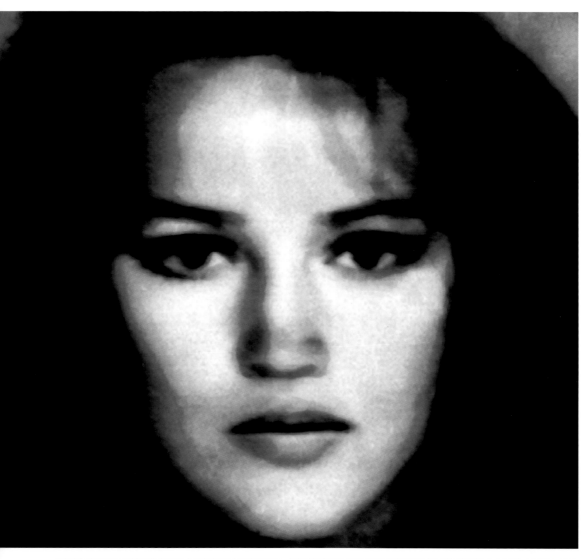

NANCY BURSON. *SECOND BEAUTY COMPOSITE (JANE FONDA, JACQUELINE BISSET, DIANE KEATON, BROOKE SHIELDS, MERYL STREEP)*, 1982. COMPUTER-MANIPULATED IMAGE. Courtesy the artist.

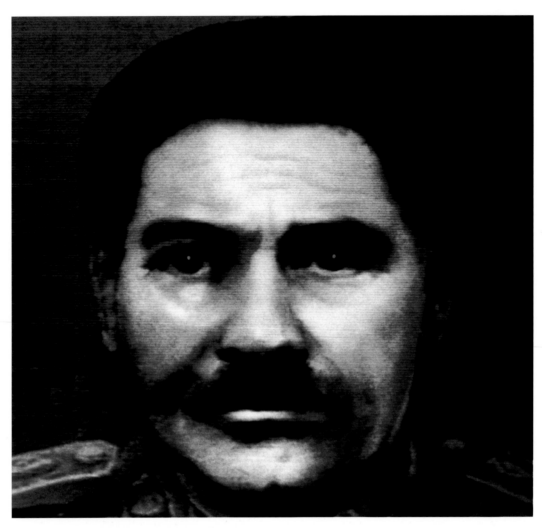

NANCY BURSON. *BIG BROTHER*. 1983. COMPUTER-MANIPULATED IMAGE. Courtesy the artist.

to perceive that "portraiture" in a digital medium could become a tool for far-reaching explorations related to aging, identity, family and ethnic traits, and the creation of virtual "individuals."

By the late 1970s, she was working with programmers Richard Carling and David Kramlich at the Massachusetts Institute of Technology, using video technology to put photographs into the computer where they could be manipulated and "aged." To create algorithms that would render the transformations she needed, she studied the ways facial features generally change over time, but she also looked at specific sets of parents to find morphological clues about how their children's features would change as they aged. On behalf of families searching for missing children, for example, Burson and Kramlich began to make images that purported to show what subjects might look like many years after they disappeared, which could be used to help find them.

Burson also began to use the computer to merge features of different individuals, creating typological portraits. Her hope was to represent in a single portrait small clusters of figures who shared particular kinds of cultural or political power. Among them was *Big Brother*, a composite image of the face of totalitarianism that combined the features of Hitler, Stalin, Mussolini, Mao, and Khomeini. Burson's typological portraits were especially appealing to journalists, since they seemed to offer a photographic alternative to the usual, and visually uninteresting, technique of representing the data collected by polls and surveys. With simple digital tools available to artists in the early 1990s, many magazines commissioned photo-illustrations, inspired by Burson's work, that purported to be portraits averaging the physiognomic traits of different types: the "face of America" was especially popular. Burson's work hinted at the growing influence of biochemistry in expanding traditional art forms.

For as long as artists have observed nature, they have been fascinated by instances of metamorphosis. One of the first consumer-level applications of digital technology to film and video was the creation of algorithms that managed the visual metamorphosis of one form (usually a head) into another, known popularly as "morphing." Artists soon began to use digital tools to create still photographic images that appear to capture key moments in a morphing sequence. Dissatisfied with simply tweaking reality photographically, for example, photographer Daniel Lee began to work with the computer to create images of "something people have had no experience of in the past." In 1993, he created a series of "portraits" that he called Manimals (the word itself morphs), which were based on the twelve signs of the Chinese zodiac. The series explores both the Chinese idea that a person exhibits traits of the sign under which he or she was born and Lee's idea that there is a fine line between human beings and the lower animals. The portraits are made by stretching and blending facial features of the models Lee photographed. Lee's riveting portraits are only one example among many in which artists use the tools of digital photography to combine—with varying degrees of seamlessness—physical attributes of humans and animals.

In 2000, photographer Chris Dorley-Brown set out to create a portrait of the English town of Haverhill. During á period of three months, he moved a portable studio to various locations around the town, photographing 2,000 people in the process. By morphing people of similar age and gender, he created a series of portraits that showed what the average male adolescent, for instance, looked like. In the final morph, which combines all 2,000 residents, the details such as hair and clothing that

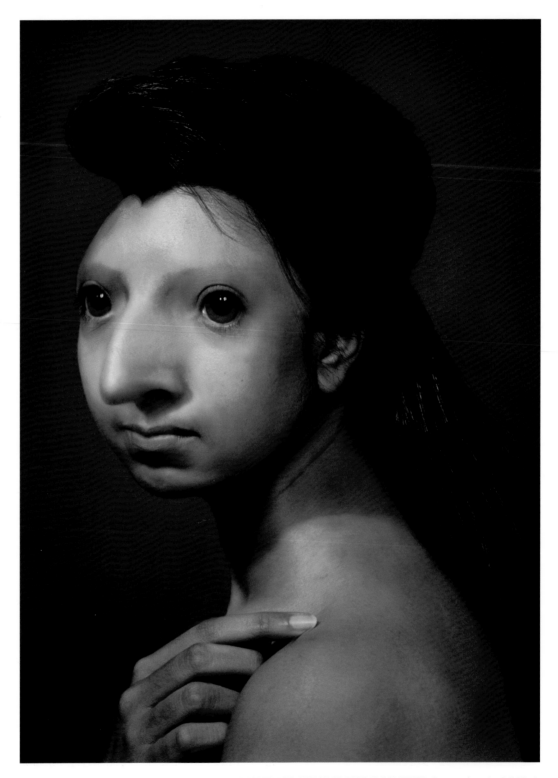

DANIEL LEE. *1957 - YEAR OF THE COCK*, FROM THE MANIMALS SERIES, 1993. EKTACOLOR PRINT, 30 X 24 INCHES. Courtesy the artist, O.K. Harris Works of Art, New York, and Nichido Contemporary Art, Tokyo.

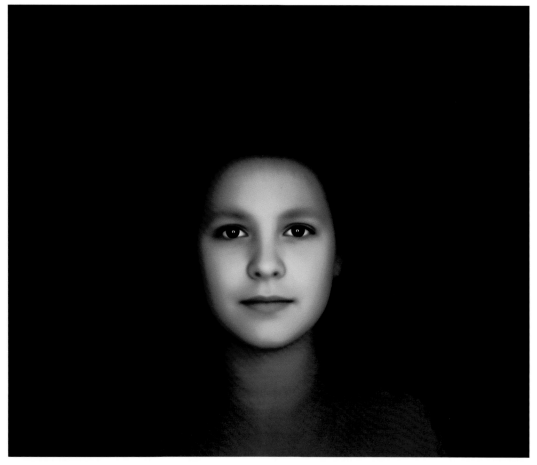

CHRIS DORLEY-BROWN. *2000*. FROM THE SERIES HAVERHILL2000, 2000–01. DIGITAL PHOTOGRAPHIC MORPH. Copyright Chris Dorley-Brown and Haverhill Town Council.

might distinguish an individual melt into the background, revealing a face that is remarkably serene, almost angelic.

While most artists in this section have used morphing techniques to create a believable image, Jason Salavon combines images by mathematically averaging the pixels in the image. He has combined pictures of kids with Santa, homes for sale, high school portraits, and both hardcore and softcore pornographic images. In *Every Playboy Centerfold 1988–1997*, he mathematically averaged more than a hundred images. As viewers, we are left with mere suggestions of the original subject matter: a tilt of the head, or a wisp of hair.

In the twentieth century, biologists unraveled the mysteries of genetics, demonstrating that living beings transmitted characteristics through the mechanism of DNA. In the twenty-first century, biologists have begun to create genetically engineered organisms by literally changing DNA sequences. The artists in this section have used the computer to explore identity through combination and transformation. The faces we see are chimeras, statistical artifacts of the digital age.

JASON SALAVON. *EVERY PLAYBOY CENTERFOLD
1988–1997*, 1998. CIBACHROME, 48 X 22 INCHES.
Courtesy the artist.

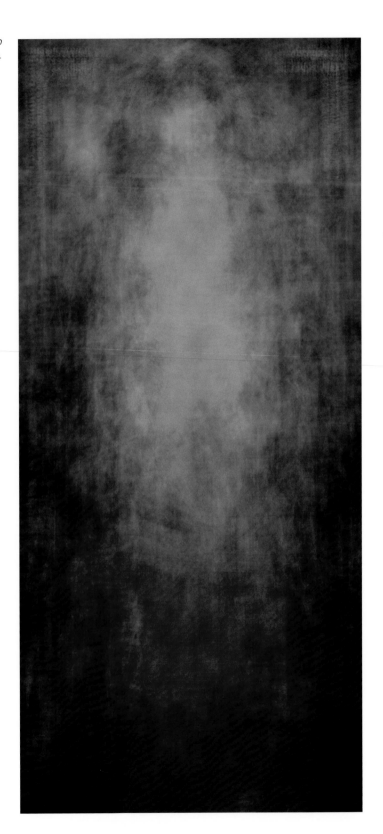

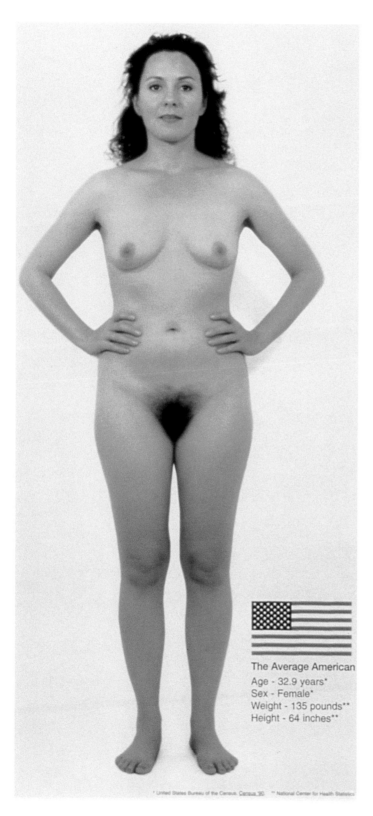

The Average American
Age - 32.9 years*
Sex - Female*
Weight - 135 pounds**
Height - 64 inches**

* United States Bureau of the Census, Census '90. ** National Center for Health Statistics

MEG CRANSTON. *THE AVERAGE AMERICAN*. 1996. C-PRINT. 72 X 37 INCHES. Courtesy the artist and the Rosamund Felsen Gallery, Santa Monica.

While many of the images of women in this book strive to produce an "ideal" (as envisioned by the mostly men who create them), Cranston produced an image that attempts to portray the average American. She used data from the 1990 census to determine the characteristics of the average American woman, from age (32.9 years) to the dimensions of her body, and color of her eyes, hair, and skin. This image is in some ways analogous to the MRI images used in medical diagnosis. Just as MRI images are constructed from generated data, so too has Cranston fabricated an image based on data collected by the census.

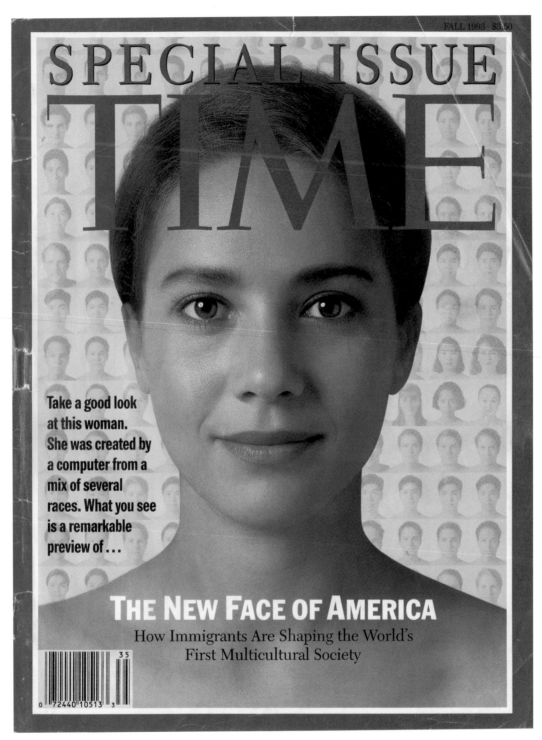

The cover of *Time*'s special issue of Fall 1993 used a digital composite as a metaphor for the "New Face of America." It is composed of features of women who are Anglo-Saxon (15%), Middle Eastern (17.5%), African (17.5%), Asian (7.5%), Southern European (35%), and Hispanic (7.5%), the projected offspring of multicultural America. © Time Life Pictures/Getty Images.

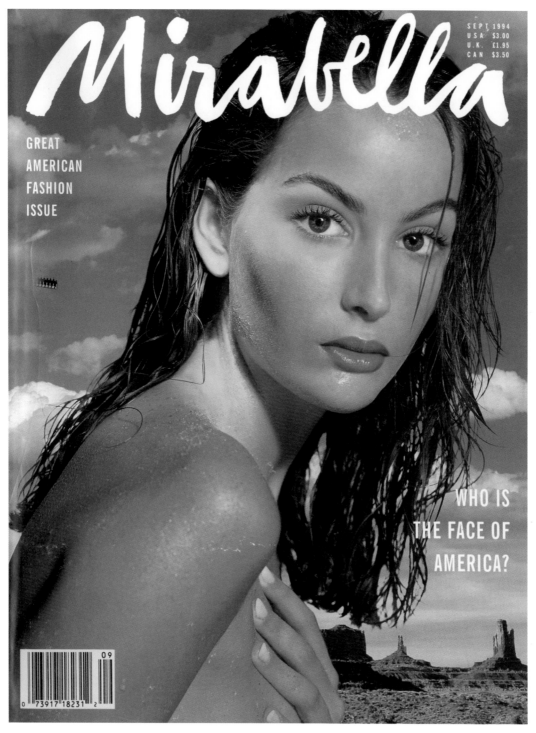

Commissioned by *Mirabella* magazine in 1994 to photograph the iconic face of American beauty, Hiro photographed several women and digitally recombined them, choosing parts from each that he found appealing. Note the microchip floating in the sky. Courtesy Hiro.

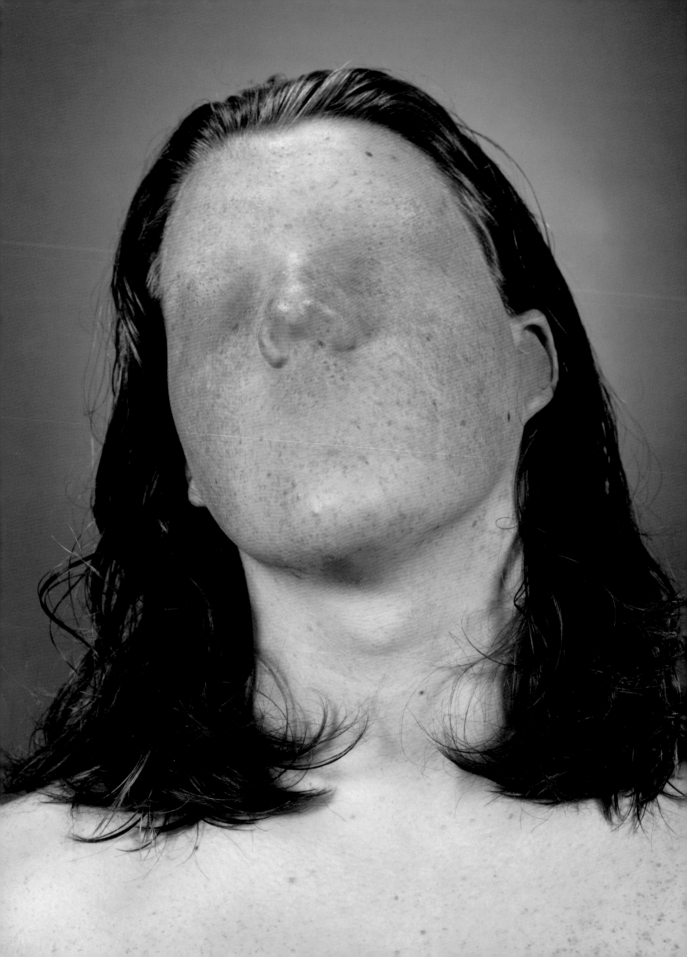

The Body
ELECTRIC

Digital photography, with its ability to shape the image to the vision of the photographer, is the ideal medium for a culture that encourages us to think of the self as a shape-shifting entity, one in which celebrities frequently change the appearance upon which their fame is built. In photography, the body is often a symbol of the self, and in digital photography, the body is often distorted, sometimes in disturbing ways. The work of Aziz + Cucher renders the body with subtle, but nonetheless eerie, changes. Anthony Aziz and Sammy Cucher began their collaborations in 1992 with the series Faith, Honor, Beauty, in which they photographed men and women in heroic poses and employed a conventional airbrush artist to remove the nipples and genitalia of their subjects. Upon seeing the images, a friend suggested that they turn to digital technology, which they did for the series Dystopia, from which the image *Rick* is taken. In Dystopia, sense organs are erased, leaving creepily smooth

AZIZ + CUCHER. *RICK*, FROM THE SERIES DYSTOPIA, 1994. C-PRINT, 50 X 40 INCHES. Courtesy the artists and Henry Urbach Gallery, New York.

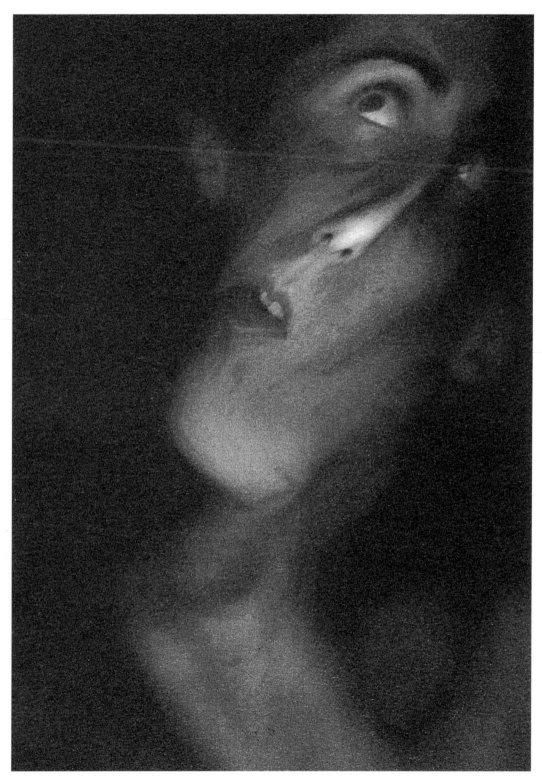

SUSAN SILTON. *SELF-PORTRAIT #5*. 1995. GICLÉE PRINT ON RIVES BFK, 12$\frac{1}{2}$ X 9$\frac{1}{2}$ INCHES. Courtesy the artist.

PAUL THOREL. *REGARDEZ MADAME ! L'ESCARGOT VOLA.* 1988. GELATIN-SILVER PRINT, 19⅝ X 19⅝ INCHES. Courtesy the artist.

patches of skin where there were once eyes and mouths. When questioned about their ideas about the human body, they say, "We take for granted that it is the seat of our biological identity, and the container—if not the creator—of consciousness. But more than anything it is for us an icon on to which many conceptual and visual metaphors can be inscribed, and therefore it has been the 'raw material' from where our work has originated." Although they work with the computer, it is the photographic nature of their work that is most important to Aziz + Cucher: the physical presence of their prints and their ability to create a sense that there is a real object rather than a manipulated image portrayed.

Rather than using a camera to create self-portraits, Susan Silton uses a flatbed scanner, designed to scan a photograph or a sheet of paper by moving a sensor across its surface, a process that usually takes several seconds. By moving her head as it is being scanned, Silton changes its shape: "It is my inclination to mistrust the surface of things."

Paul Thorel uses the computer to create a sense of mystery in his images by selectively hiding and revealing areas, showing "faces in transformation at the moment before an expression fades." Like the Surrealists, Thorel is fascinated by chance. Man Ray liked photography in no small part because he was never sure of the image he would get when he pressed the shutter, creating for him a sense of randomness. Thorel is working against the essential nature of digital photography, which gives the artist control over every last pixel in the image and makes any sense of chance illusory.

Other photographers have manipulated the body to such an extent that it is barely recognizable, festooning it with baroque ornamentation in the kind of visual bric-a-brac that can be easily generated by photo-manipulation programs. In the latter vein, Nick Knight has created a series of heads under the title *Sweet*, while Bettina Pousttchi delves deep into the human body. She begins with photomicrographic images of human blood cells, then processes them with the computer into the seemingly abstract work shown here. Most photo-manipulation programs have tools that mimic procedures once thought to be nonphotographic, such as painting or airbrushing, which artists today use to transform photographic images into nonphotographic ones. Pousttchi's images recall Georgia O'Keeffe's flower paintings, suggesting that the body's sensual nature is more than skin deep.

Also concerned with skin, Thomas Ruff created his series Internet Nudes by downloading pornographic photographs off the Internet, blurring or otherwise visually obfuscating them, and printing them at an epic scale. By denying the viewer quick and easy access to the images (the hallmark and lure of the online porn industry, the most profitable of all online endeavors), Ruff makes all the more apparent the ease with which images are disseminated through the new electronic networks. By degrading the image, by blurring its surface, Ruff reinforces his belief that photography can ultimately capture only the surface of its subjects.

Maki Kawakita has taken the digital retouching techniques employed by fashion photographers to extreme lengths, transforming models into "authentic mannequin girls." Her image *Life-size Barbie* is born from Kawakita's belief that people should embrace the mass culture within them. Youth build their identity through popular culture, and pop culture is moving us towards "super-artificiality."

THOMAS RUFF. *NUDES YV16*. 2000. LASERCHROME AND DIASEC. 61 X 43¼ INCHES. Courtesy David Zwirner Gallery, New York, and Contemporary Fine Arts, Berlin. © 2005 Artists Rights Society (ARS), New York/VG Bild-Kunst, Bonn.

BETTINA POUSTTCHI. *VERA NATURELLE*. 1999. DIGITAL PRINT BEHIND PLEXIGLAS. 50 X 50 INCHES. Courtesy the artist and Buchmann Gallery, Cologne.

NICK KNIGHT. *SWEET*, FOR SHOWstudio.com, 2000. DIGITAL PHOTOGRAPH. Courtesy the artist.

DIETER HUBER. *KLONE # 5*, 1994–95. C-PRINT/ALUCUPOND, 27^1/$_2$ X 45^1/$_4$ INCHES. Courtesy the artist.

DIETER HUBER. *KLONE # 7*, 1994–95. C-PRINT/ALUCUPOND. 35^1/$_2$ X 47^1/$_4$ INCHES. Courtesy the artist.

Dieter Huber took these same retouching techniques a step further to create his impossible "Klones." His grotesque anatomical studies may initially recall a carnival freak show or museum of curiosities. But in the end, they are no more unlikely than Kawakita's impossibly perfect models, or even those highly retouched photographs in fashion magazines.

It is our peculiar fascination with celebrity that may be responsible for a culture in which appearance is a shimmering illusion, one that changes from day to day. The pop singer Madonna first made us aware of this, constantly changing her appearance and so her persona—the essence of celebrity for most famous people. Today everyone from sports figures using steroids to everyday people using plastic surgery has experimented with altering their shape and identity. So it seems that the transformative power of digital photography is ideal in an age in which the body itself is an unstable and changeable object.

MAKI KAWAKITA. *LIFE-SIZE BARBIE*, 2002. INK-JET PRINT, 40 X 30 INCHES. Courtesy the artist.

AVATARS

Today, the very nature of what constitutes a photograph is open to debate. Once, the definition was quite clear: an image created through the photo-mechanical process of exposing film to light, then processing the film to create a photographic print. Creating a photographic image without a subject was simply not possible; although the Photo-Realist painters of the 1960s painstakingly painted canvases that at first glance looked like photographs, closer inspection uncovered their true nature. Today, computer programs are able to create images that appear photographic, although they have no true "subject." And, because they are composed of the same "stuff" as digital photographs—binary digital information—it is more difficult to distinguish the two. Early attempts at computer modeling were quite crude, but recent advances in hardware and software have been able to create images that are indistinguishable from photographs taken with a camera.

KEITH COTTINGHAM. *UNTITLED (TRIPLE)*. FROM THE SERIES FICTITIOUS PORTRAITS. 1993. DIGITALLY CONSTRUCTED PHOTOGRAPH. 46 X 38 INCHES. Courtesy the artist and Ronald Feldman Fine Arts, New York.

"Though cloaked in photographic reality, the series Fictitious Portraits have no actual models; rather, they are Selves who have no reach beyond the two-dimensional. But their very appearance in photographs convinces us to believe that they exist in the world as we do. The artifice in this is laid bare as the more closely the fictive figures are scrutinized, the more they begin to visually deconstruct. They mimic and contradict at once the veracity of photographic reality."
—Keith Cottingham

KYOKO DATE is a virtual pop star—an *idoru*—introduced by computer scientists in Japan in 1996. Among the first, her movements were awkward and ungainly, but her successors are becoming more and more lifelike. Copyright HoriPro, Inc. All rights reserved.

"Don't look at the *idoru*'s face. She is not flesh; she is information. She is the tip of an iceberg, no, an Antarctica, of information."

—William Gibson, *Idoru*, 1996

"Anyone who thinks that I am 'non-existent' because I am a virtual idol may believe that I exist only in the personal computer or in the world of computer graphics. But those who think that Kyoko Date is someone they can relate to may believe that I am like a pen pal people used to have when it was cool to have pen pals. Kind of like a creature living in people's hearts. It's hard to explain."

—Kyoko Date

While artists such as Keith Cottingham have been grappling with what is and is not a photograph, the end of the twentieth century witnessed the birth of the "avatar," computer-generated personas that inhabit the virtual spaces that are quickly becoming a part of our everyday experience. Although they appear to have been created photographically, Cottingham's "portraits" are actually montages, assembled in a computer from anatomical imagery, sculpted clay models, and photographs of facial features, both the artist's and others'. Their heritage is not the silver halide of photographic film, but the silicon of computer chips. Throughout history, artists have portrayed individuals with idealized, or "generalized," features: Botticelli's Venus is no more convincing as a portrait of a particular person than are Keith Cottingham's portraits of adolescent boys who never existed. While Botticelli's characterless faces are familiar artistic conventions, however, we are disquieted by Cottingham's images because they exist somewhere between photography's definitiveness ("taking" a picture) and painting's suggestiveness ("making" a picture).

Works like Cottingham's foreshadowed the appearance of the "avatar," the virtual—that is, digital— incarnation of a human being. Graphical avatars began to appear about 1980 as "game pieces" in rudimentary MUDs (variously rendered as Multiple User Dimension, Multiple User Dungeon, Multiple User Dialogue, or Multi User Domain), virtual spaces in which people could adopt computer personas and interact with one another. MUDs were at first limited to written dialogue and descriptions of environments, but soon they were being produced as elaborate audiovisual computer games. As the bandwidth of the Internet grew and computer processing speed increased, it became possible to transmit images, and online worlds began to contain images, and so avatars were born. Avatars are made up of a 3-D "wireframe"—a sort of virtual skeleton—over which a texture or skin is wrapped. This seems a particularly apt metaphor, as avatars are all surface, no more than skin.

Beginning in the 1990s, the Internet became home to a number of avatars. Readers of William Gibson's 1996 novel *Idoru*, which chronicles the career of Rei Toei, a Japanese pop star who exists only in virtual reality, will be familiar with the idea. Gibson was inspired by the scads of pretty teenage girls, called *idorus*, who were groomed into pop stars overnight (often without doing their own singing) by Japanese record producers in the 1990s. It was a small step for computer scientists, using powerful computers, to create virtual *idorus*. This was a case where fact was to mirror fiction, although none of the actual avatars that have been created so far possess the mysterious soul of Rei Toei.

Thus, in the same year that *Idoru* was published, an actual virtual *idoru* appeared on the Internet in the form of Kyoko Date, who released an album called *Love Communication*. Date quickly became a pop icon in Japan, giving interviews (her ambition was to be a private detective when she grew up) and appearing in music videos. Like all *idorus*, Date quickly faded in popularity, but her brief career suggested that people were ready to be entertained, educated, and instructed by avatars (whether they are ready to be led by them is a chilling question), and gradually others were "born": Ananova, a virtual newscaster; Mya, a virtual personal assistant; and Webbie Tookay, a virtual fashion model who, for a while, was represented by a prominent New York City modeling agency. In a culture obsessed with the ideals of female beauty, it is hardly surprising that in 2004, online beauty contests emerged featuring virtual models from around the world. Today, the availability and sophistication of digital modeling software has

ANANOVA. Courtesy ananova.com.

Around the same time as Webbie Tookay appeared as the first virtual model, Ananova became the first virtual newscaster. By late 2004, more powerful computers and rendering software were widely available, and there were hundreds of virtual models.

MYA (left). Courtesy Motorola. In 2000, some companies experimented with virtual characters as digital agents for their commercial services. Mya was intended to help Motorola customers check e-mail and book airplane flights, among other things.

WEBBIE TOOKAY (right). Courtesy Steven Stahlberg. Webbie Tookay, whose name is a play on the year 2000 (*2K*), was the first computer-generated model to be represented by a modeling agency.

MAMEGAL. Koji Yamagami of Beans Magic Co. Ltd. is one of many designers to use new digital modeling and rendering software to create virtual models, with the hope that they will be cast in films or commercials. Mamegal was created using 3-D Studio Max and a new rendering system called Brazil.

created an explosion of designers of virtual humans, mostly female, which are offered up for use in print and television advertisments. Predictably, the bodies of most of these computer-generated women resemble the flesh-and-blood models who inhabit popular culture. One such creation is Mamegal, the product of Koji Yamagami of Beans Magic.

A press release for Ananova, a virtual newscaster that debuted in April 2000, stated that "Ananova is the human face in front of Ananova.com's real-time news, information and e-commerce services. She responds with relevant emotions and actions to the information she delivers using real-time data files, text-to-speech technology and image-rendering techniques." Whatever Ananova is, she is not the "human face" of anything. And yet, is a photographically detailed image of Ananova any less a valid portrait than, say, a photograph of one of the blandly handsome men or women who read the news on TV? Perhaps the world of virtual avatars is merely a reflection of the race of flesh-and-blood avatars created by our entertainment-based culture.

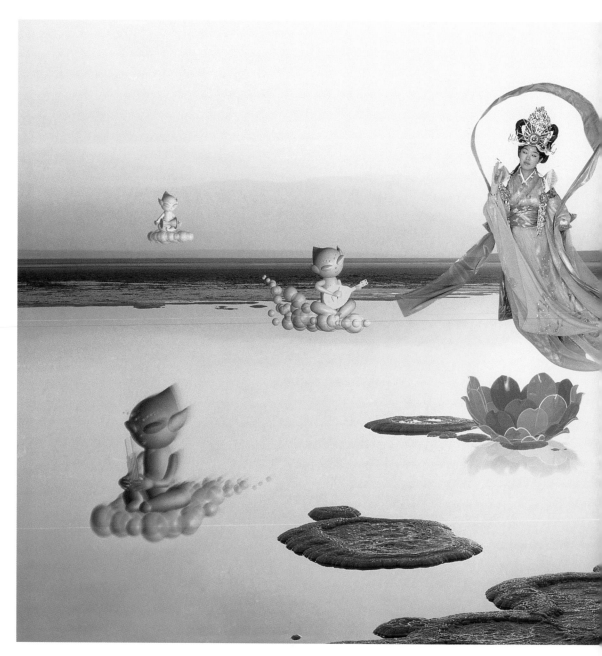

MARIKO MORI. *PURELAND*. 1997–98. GLASS WITH PHOTO INTERLAYER. 5 PANELS. 120 X 240 X ⁷/₈ INCHES. Courtesy the artist and Deitch Projects, New York.

The title of this photograph refers to the Amitabha Buddha's Western Paradise, where the faithful are reborn to await final enlightenment. Enlightenment and technology run through the work of photographer Mariko Mori. In this image, she places herself among digitally created creatures who resemble popular conceptions of alien beings or even characters from the video games that pervade youth culture. Mori may be suggesting that we can achieve enlightenment in the modern age through music and pop technology. Music has been a part of spiritual rituals for ages, though it has never been quite so apparent as today, with ephemeral electronic music like "trance" music, and portable music players that allow the wearer to block out the world around them. Does the appearance of icons in this image suggest that we can achieve paradise through the use of technology, or that we must strive to achieve a balance with technology? No one can say for sure, but what is clear is that Mori feels strongly that our future is intimately tied to technology.

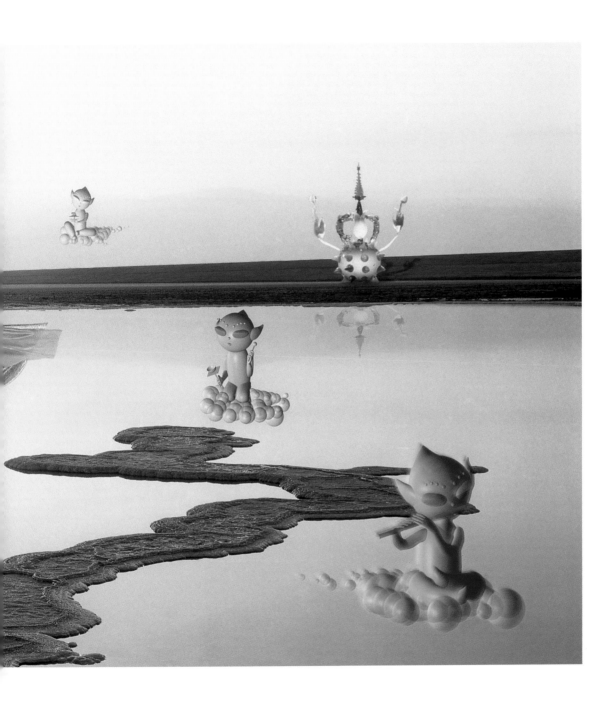

<div align="right">

The Technological
SUBLIME

</div>

Perhaps we invented digital photography to photograph the future. Certainly, the coincidence of the rapid growth of digital technology in the last decade of the twentieth century caused many to feel that we live in a time of exciting, dramatic, and possibly dislocating change that will have a deep effect on everyday life. While some artists have reacted to the mood of the moment by returning to the roots of their craft—there is even a revival of interest in the earliest photographic techniques of the mid-nineteenth century—others have embraced the newest science and technology, using new methods to create new

LORETTA LUX. *SPRING*, 2001. ILFOCHROME PRINT, 15 X 15 INCHES. Courtesy the artist and Yossi Milo Gallery, New York.

MARIKO MORI. *LAST DEPARTURE.* 1996. CIBACHROME PRINT AND ALUMINUM. 84 X 144 X 36 INCHES. Courtesy the artist and Deitch Projects, New York.

visions of what might be. Looking at the work of the new futurists, it is not always easy to distinguish the utopians from the dystopians. It would be easy to say that Mariko Mori longs for the future, while Jeff Weiss fears it. But Mori's work has an undercurrent of unease, while Weiss's catalog of horrors is somehow idyllic. It might be more fair to say that both look toward the future in general, and technology in particular, with varying mixtures of anticipation and dread, much like the shell-shocked children in Loretta Lux's work. Lux, who was trained as a painter, creates images that may or may not be called portraits. While they depict specific children—sons and daughters of the photographer's friends—they seem to suggest archetypes more than individuals. Lux's vision may lie somewhere between that of Weiss and Mori. Her children seem simultaneously innocent and wise beyond their years.

Mori's early part-time work as a fashion model gave her a sense of the power of her own image; placing herself in her own art, she becomes a medium or lightning rod for notions of culture and identity. Her work draws on pop culture and science fiction, our cultural fascination with technology, as well as Shintoism and Buddhism. Mori's early artwork consisted of photographing avatar-like versions of herself in fantastic self-made costumes on the streets of urban Japan. As she became more spiritually inclined toward Buddhist ideals, she also moved to the computer to create her hyper-real tableaux, modifying not only her apparel, but her environment as well.

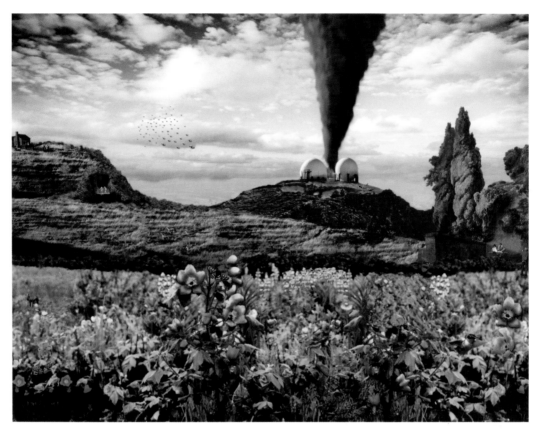

JEFF WEISS. *BRONCO*. 1997–2000. C-PRINT, 52 X 67 INCHES. Courtesy the artist.

Last Departure is a photograph of an elaborately costumed Mori in Kansai International Airport. She stands clad in a self-designed futuristic outfit, flanked by transparent repetitions of herself, and the globe she holds, suspended between her hands, contains a repetition of the scene, complete down to the representation of Mori holding the globe, an allusion to the infinite. It is a terminal moment in a cold place, but contains hints of reincarnation and eternal renewal. *Mirror of Water*, from the series Nirvana, is more overtly spiritual, a shimmering futuristic vision (complete with a "UFO" containing a "tea ceremony of the future") of multiple Moris designed to represent aspects of her being in an ancient French cave. As she says, "I try to develop my own future vision and utopian ideas— my own interpretations of tradition."

In *Bronco*, Jeff Weiss presents a landscape beset with all manner of man-made disasters: helicopters that swarm like angry bees, industrial accidents, and shootings. Yet in spite of this, the image is composed of cheery pastel tones under a cloud-dappled sky, with wildflowers blooming in the fore-ground. His image *Suburban* presents an idyllic landscape—populated with houses, office buildings, and joggers in pastel sweat suits—into which an army of paratroopers descends. On closer inspection, the office tower contains not only office workers, but also a couple in their bedclothes, watching what appear to be surveillance monitors, and computers displaying financial data and pornography. A

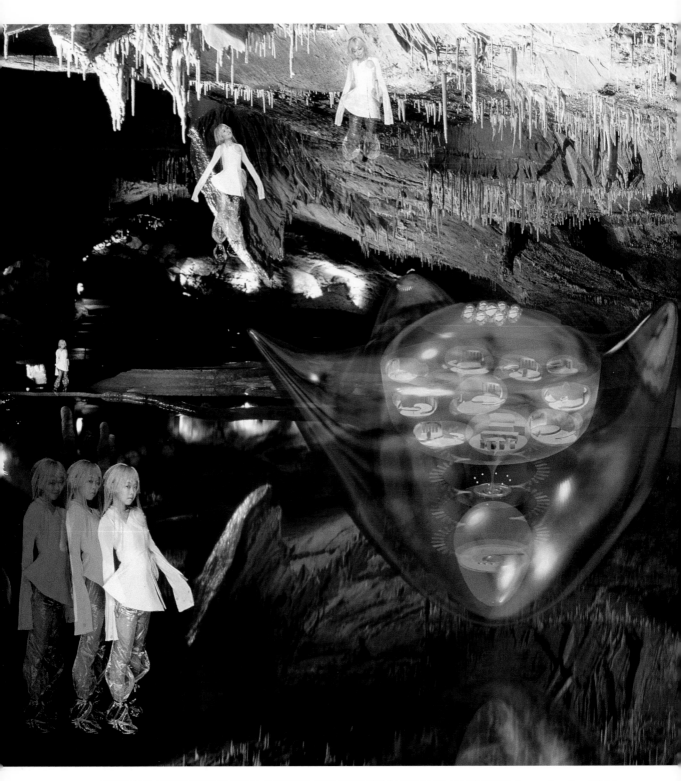

MARIKO MORI. *MIRROR OF WATER*. 1997–98. GLASS WITH PHOTO INTERLAYER. 5 PANELS. 120 X 240 X ⅞ INCHES. Courtesy the artist and Deitch Projects, New York.

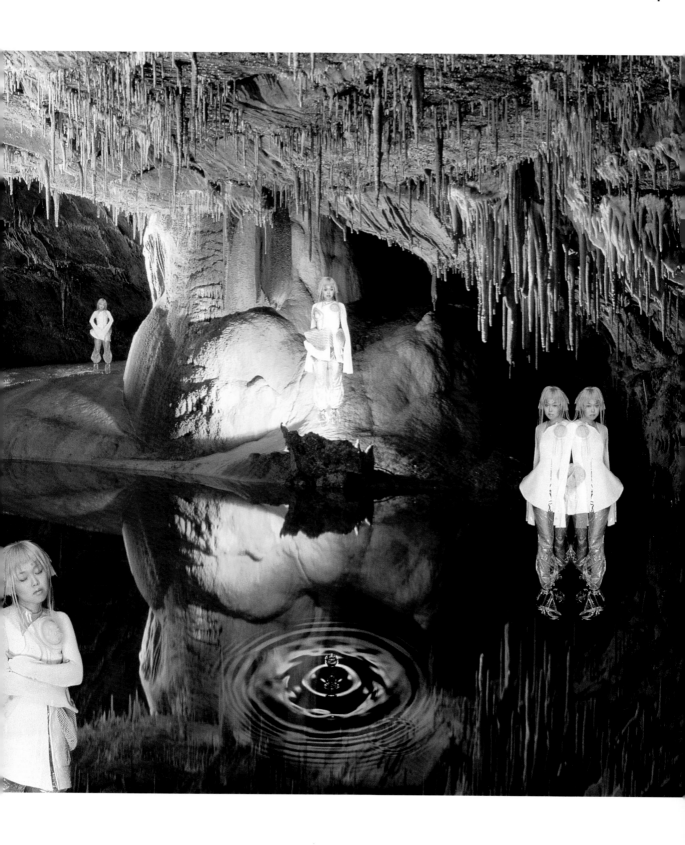

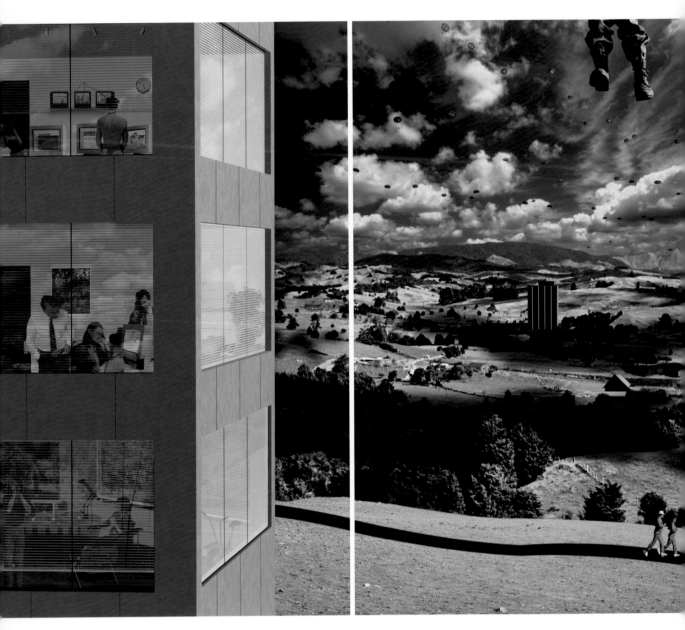

JEFF WEISS. *SUBURBAN*. 1999–2000. C-PRINT. 66 X 90 INCHES. Courtesy the artist.

woman peers in from outside, while other people in the building play video games, and a tractor outside appears to be pulling a house out of a ditch. As with *Bronco* (the titles of these works, like the others in this series, are all the names of sport utility vehicles), there is tension between the natural and the man-made, with a sense of impending misfortune. Ostensibly, Weiss's vision is much darker than Mori's, but perhaps the underlying message is not so different: nature endures.

Mori and Weiss use glimpses of reality to construct their worlds; the vision reproduced here of Craig Kalpakjian is completely fabricated inside the computer, although his images appear to be photographs. The work of the artist team of Anthony Aziz and Sammy Cucher combines photographs of human skin with computer-generated scenes. Both create interiors that are flawed by excess: Kalpakjian's lack human warmth, while Aziz + Cucher's have perhaps too much. Kalpakjian's interiors are of offices designed for human use, yet they are suspiciously devoid of any human trace: a scuff mark left by a shoe, a discarded gum wrapper, or even the tiniest speck of dirt. They exist purely as information, the mental projections of an almost insanely rational mind.

By contrast, the interiors created by Aziz + Cucher are, if anything, too specific, too intimate. The human trace—walls, ceilings, and floors covered with human skin—is, in this case, overwhelming. Today, the boundaries between human and nonhuman have grown unstable: we have machines that can talk, think, and move like human beings, while we implant more and more technology—in the form of insulin pumps and pacemakers—into our bodies. We can grow skin, and perhaps soon organs, or even entire cloned human beings. Aziz + Cucher's work evokes this sense of science and medicine gone awry.

The theme of engineered living organisms runs through the work of Patricia Piccinini, who used the computer to generate a macabre mouse, referring to a 1997 experiment at the University of Massachusetts where scientists grew tissue in the shape of a human ear for eventual implantation onto a human being. Piccinini writes: "I have to admit to feeling a certain sympathy for laboratory rats and for models. Both are pieces of meat. They are organic vessels destined to contain the desires of those who utilize them. My sympathy does not run too deep; models get more benefits than laboratory rats and lab rats are often more difficult to like. However, both are subject to the same constant and radical transformations and both are used interchangeably, without any regard to their specific personality."

Oliver Wasow, like Aziz + Cucher, came to digital technology midcareer, and he quickly realized it was a tool that would enable him to create pictures that are "unified fragments," collages that present spatially believable images. His synthetic landscapes explore the sometimes ambiguous and sometimes strained relationship between nature and civilization, between that which is grown and that which is constructed. This tension, in the content of his work, mirrors the tension in its creation, that between the photographs he takes with his film camera, and the digital montages he carefully puts together in the computer. It is a tension evident in the image *Volgograd* showing the exterior of Biosphere 2, an entirely enclosed and self-sustaining environment where a team of eight people lived for two years. His later work shows the interiors of buildings into which nature has been placed, or in which it has intruded. These images look staged, acknowledging their digitally constructed nature.

He writes: "In the end I suppose I'm interested in the synthesis of a variety of seemingly contradictory forces: nature and culture, the past and the future, painting and photography, and, ultimately, an op-

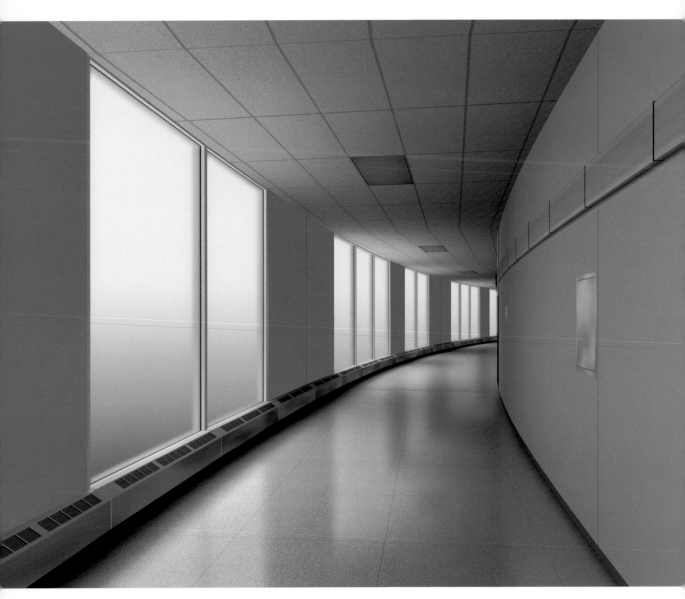

CRAIG KALPAKJIAN. *CORRIDOR*. 1997. CIBACHROME PRINT MOUNTED ON ALUMINUM. 30 X 40 INCHES. Courtesy the artist and Andrea Rosen Gallery, New York.

AZIZ + CUCHER. *INTERIOR #6*, 2000. C-PRINT, 72 X 50 INCHES. Courtesy Henry Urbach Gallery, New York.

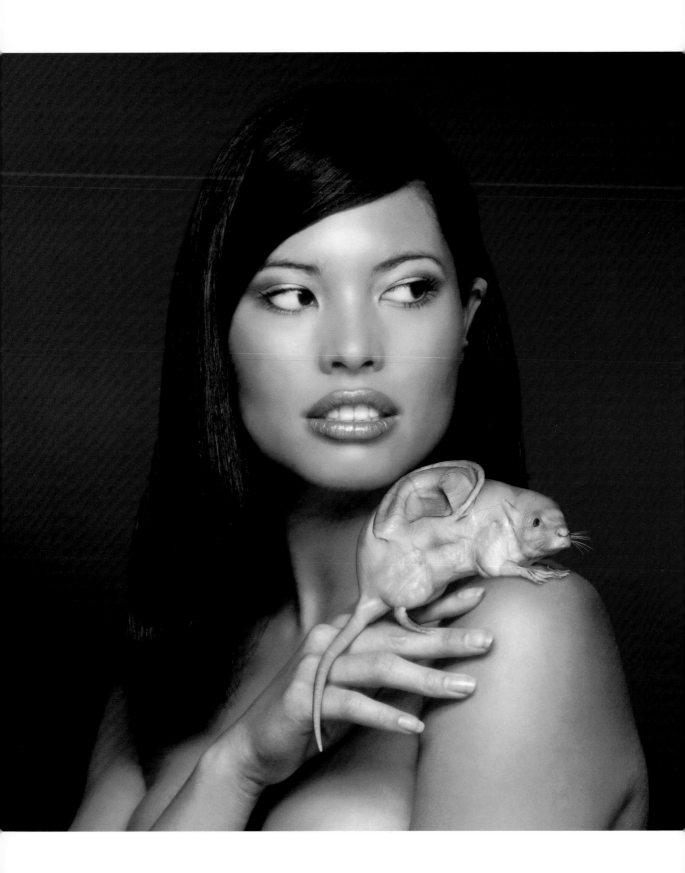

position that I suppose defines art and art making itself, fiction and reality. I try to collapse all these things into each other, creating pictures of places that are neither utopian nor dystopian but are, hopefully, beautiful, mysterious, compelling, and a little bit frightening. Much like life itself.

It is hard to say whether the artist team of AES + F is imagining the future, or just using the symbols of video games to fantasize about the present. In their series Action Half Life, they appropriate the visual language of advertising: slender, youthful models who lounge insouciantly in a barren landscape, some courageously toting futuristic-looking weapons. By placing weapons in the hands of children, AES + F suggests that the boundaries of our media environment are blurring: in an era when action heroes are elected to political office, the lines between fantasy, advertising, and video games can be said to have broken down.

In the nineteenth and twentieth centuries, science fiction writers captivated the public's imagination by predicting the fantastic machines of the future. Today, technological innovation seems boundless and instant, no longer limited to a distant tomorrow. The literature of science fiction was once a means to speculate about the future, but by the start of the twenty-first century the line between the future and present is no longer clear. Artists have responded to the relentless pace of change by imaging ways in which the present might assimilate the future, and the ways in which the future is insinuating itself into the present. The technological sublime reflects our awe in the face of technology that threatens to overwhelm us. Our most pressing concern is how to assert our humanity in the face of this onslaught.

PATRICIA PICCININI. *PROTEIN LATTICE SUBSET RED PORTRAIT*. 1997. DIGITAL C-TYPE PHOTOGRAPH. 31½ X 31½ INCHES. Courtesy the artist.

OLIVER WASOW. *MARIN COUNTY CONVENTION CENTER*, 2002. ARCHIVAL INK-JET PRINT, 30 X 40 INCHES. Courtesy the artist and Janet Borden Inc., New York.

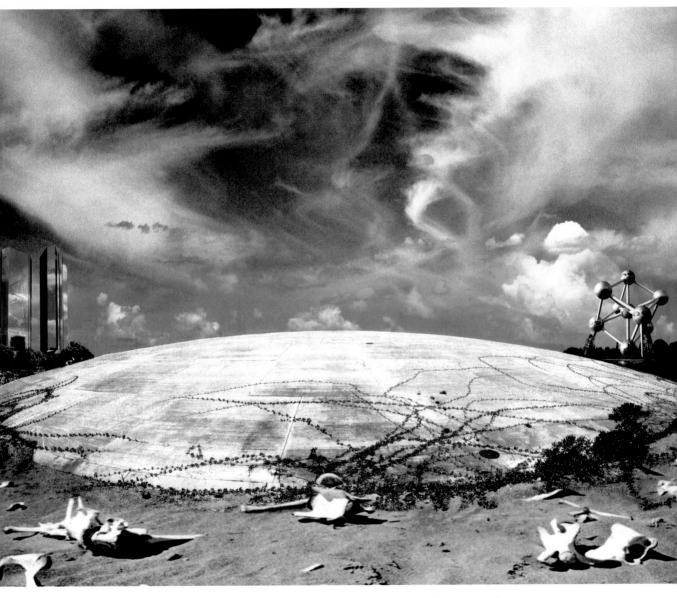

OLIVER WASOW. *VOLGOGRAD*, 1999. ARCHIVAL INK-JET PRINT, 30 X 40 INCHES. Courtesy the artist and Janet Borden Inc., New York.

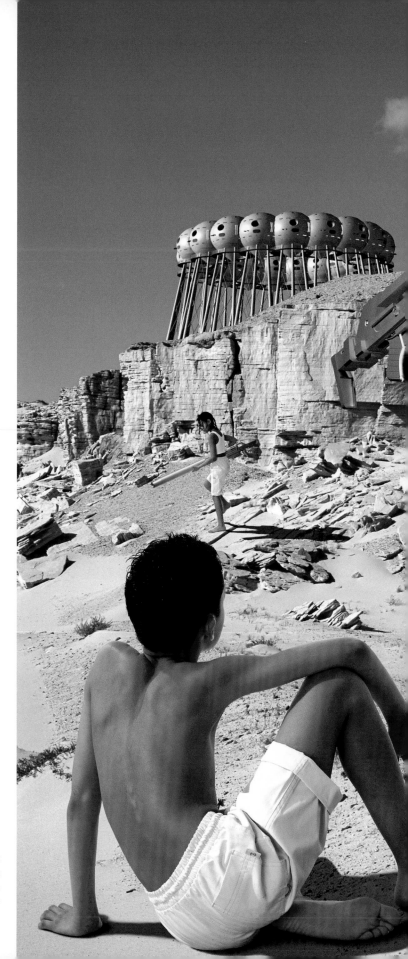

AES + F. *EPISODE 2, #12*, FROM THE SERIES ACTION HALF LIFE, 2003. C-PRINT ON CANVAS, 59 X 73³/₄ INCHES. Courtesy the artists and Ruzicska Gallery, Salzburg, Austria. © 2005 AES/Artists Rights Society (ARS), New York.

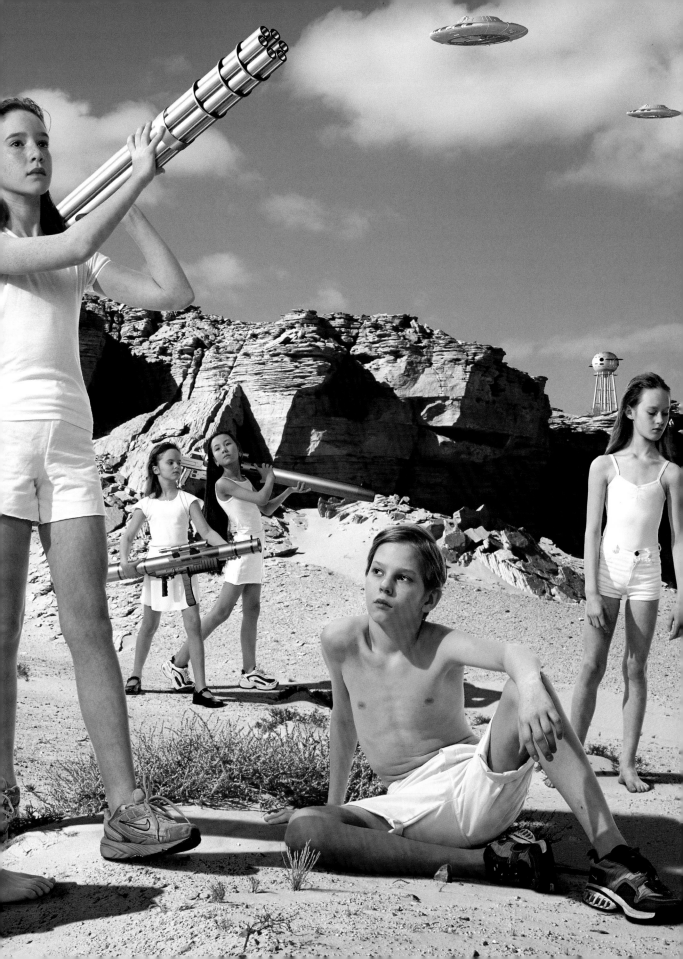

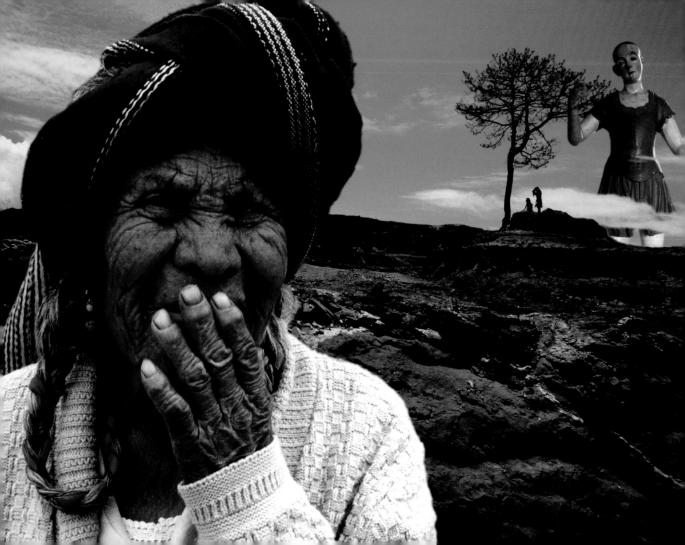

ENCHANTED
Landscapes

Until the invention of digital photography, the marvelous dream landscapes, beloved of visionary artists and writers from the Surrealists to Latin American Magic Realists, were largely out of reach of photographers. Conventional photography was poor in the techniques needed to create such landscapes— from unnatural color palettes to the seamless meshing of the real and the imagined—although photographers, from time to time, experimented with multiple exposures and other expressionist tools to portray that heightened sense of reality that characterizes visions, memories, and dreams. As Pedro Meyer, one of the pioneers of a form of Magic Realism in digital photography says in reference to critics who lump digital manipulation with older cut-and-paste collage techniques, "the digital tools allow us to have control over what and how we can alter an image, that was unimaginable in the era of analog

PEDRO MEYER. *ARRIVAL OF THE WHITE MAN, MAGDELENA PEÑAZCO, OAXACA,* 1991–92. C-PRINT, 16 X 20 INCHES. Courtesy the artist.

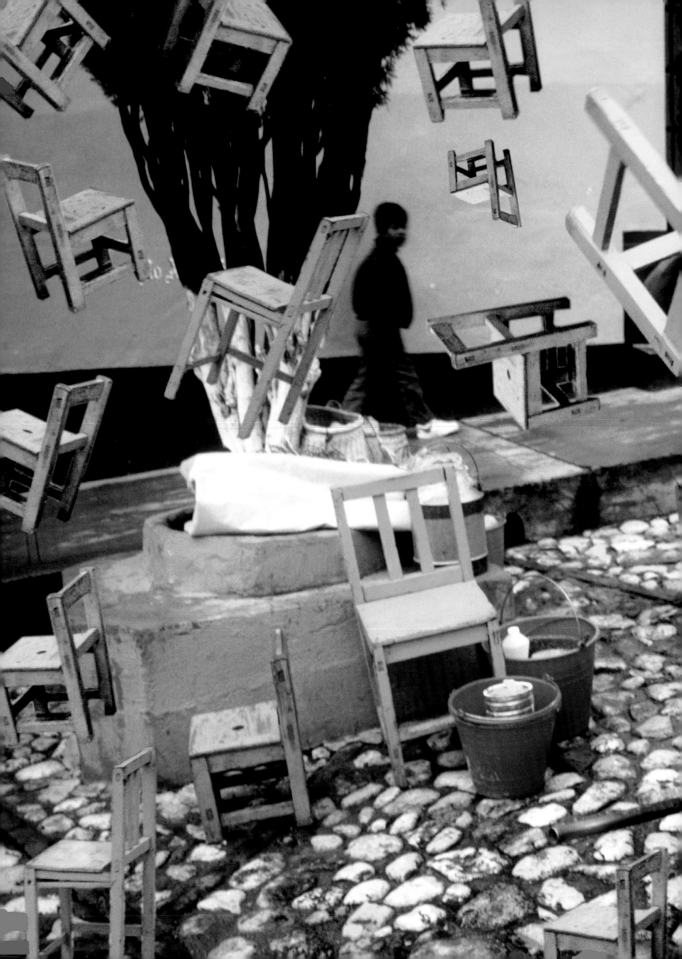

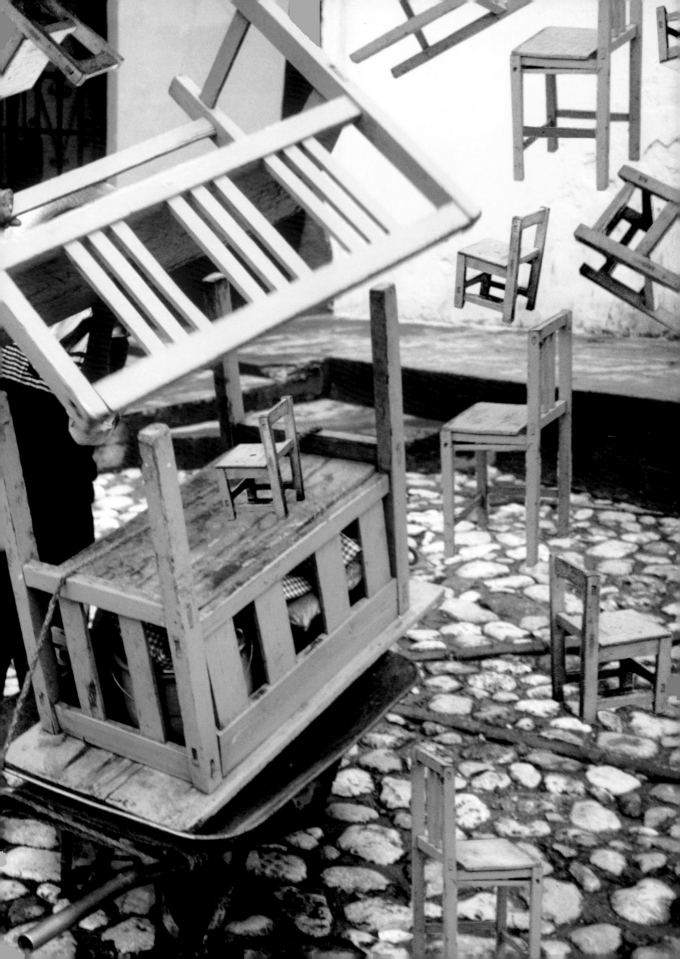

photograph." Meyer is always seeking to reveal in his images more than what the conventional camera might see: "The experience in a traditional photographic representation has been limited—although in truth the camera sees more than we do, and therefore is not limited at all—to those elements that the lens was able to capture. To the silver halide or dyes, I can now add my own memory." Meyer's "memory" is both a cultural and a personal one, focused on his native Mexico (his family emigrated to Mexico City from Madrid when he was two years old) and his adopted United States alike. One of his early works, *Arrival of the White Man*, created only a year after Photoshop was introduced, symbolizes a memory of cultural imperialism: an old Mexican woman is superimposed on a landscape near Oaxaca, Mexico. In the sky is a devotional figure of a white saint. Meyer has since created a body of far more subtle images than this, but *Arrival of the White Man* is instructive for its combination of photography, manipulated color (the green sky), and photomontage, to both express an abstract idea and to capture a mood.

Pedro Meyer once worked in the tradition of the street photographer, looking for unusual juxtapositions he might encounter serendipitously. In traditional street photographs, these juxtapositions are interesting because they did happen. But in digital photography, the artist must make the image interesting or meaningful precisely because these juxtapositions did not happen. The photographer did not stumble over a fortunate series of events, but instead assembled them deliberately.

Martina Lopez is another early adapter of digital photographic tools, and like Meyer uses digital tools to express her personal history and memories. While Meyer creates images that appear to be photographic, Lopez's artificially constructed landscapes are surreal, closer in appearance to traditional cut-and-paste collages. The black and white figures appear strangely out of place in the colored landscapes, a mix of the specific and the vague. Lopez's early digital work montaged figures from family snapshots into spaces that she created: like many other artists, she was working out her sense of loss over the deaths of loved ones. Later work, like *Revolutions in Time 2*, created from found photographs, moves into literary realms: "By extracting people from their original context and then placing them into fabricated landscapes, I hope to retell a story of their being, one which allows the images to acquire a life of their own. While the pieces from photographs verify an actual lived experience, the landscape stands as my metaphor for life, demarcating its quality, where the horizon suggests an endless time."

While Lopez's work is obviously manipulated, the work of Simen Johan is, at first glance, more believable, though his subject matter is ultimately more abstract. He takes advantage of tools and techniques not available to Meyer merely a decade earlier to create photographs that seem to answer the question, What do children's dreams look like? The answer is not what you would expect from most popular depictions of children as free of the complicated emotions and thoughts that characterize human experience. *Untitled #65* presents us with an obscure image of loss; an androgynous adolescent child—with a concentrated expression that conveys intense but contained feeling—cradling a dead sheep in a meadow. Johan's picture does not pretend to be naturalistic and is completely synthesized from bits and pieces of images that he blends and transforms: "By combining different elements, my objective is to create artificial scenarios that appear vaguely familiar and produce numerous associations." It is output onto photographic film and printed conventionally, further confounding

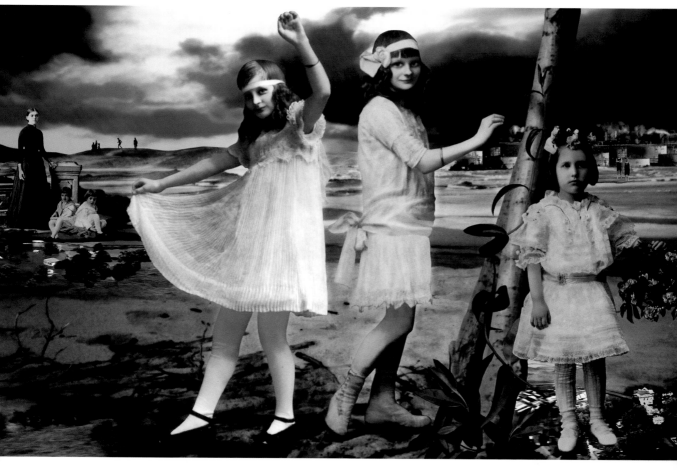

MARTINA LOPEZ. *REVOLUTIONS IN TIME 2*. 1994. SILVER DYE BLEACH PRINT. 30 X 50 INCHES. Courtesy the artist.

PREVIOUS SPREAD:
PEDRO MEYER. *EXPLOSION OF THE GREEN CHAIRS, TLAXIACO, OAXACA*. 1991–93. C-PRINT. 16 X 20 INCHES. Courtesy the artist.

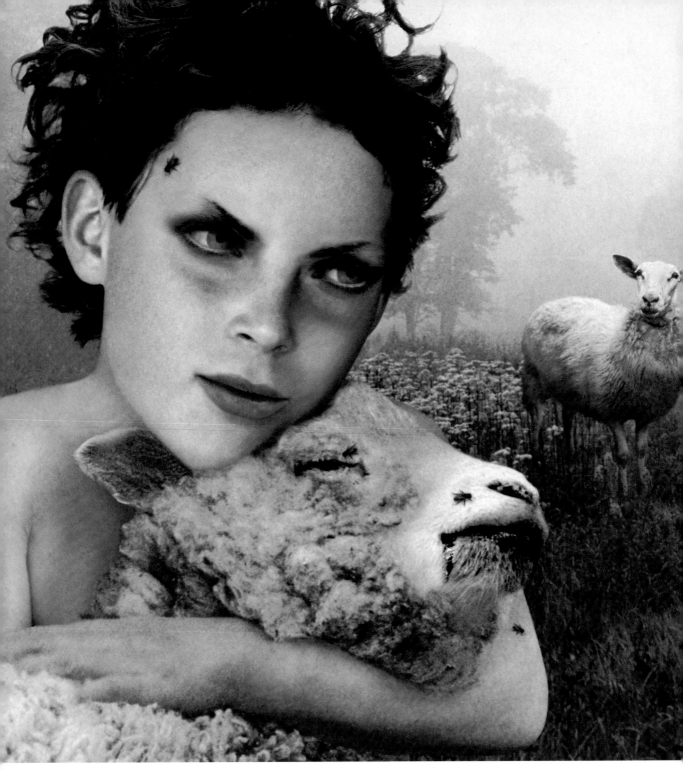

SIMEN JOHAN. *UNTITLED #65*, 1997. SEPIA-TONED GELATIN-SILVER PRINT, 19 X 19 INCHES. Courtesy the artist and Yossi Milo Gallery, New York.

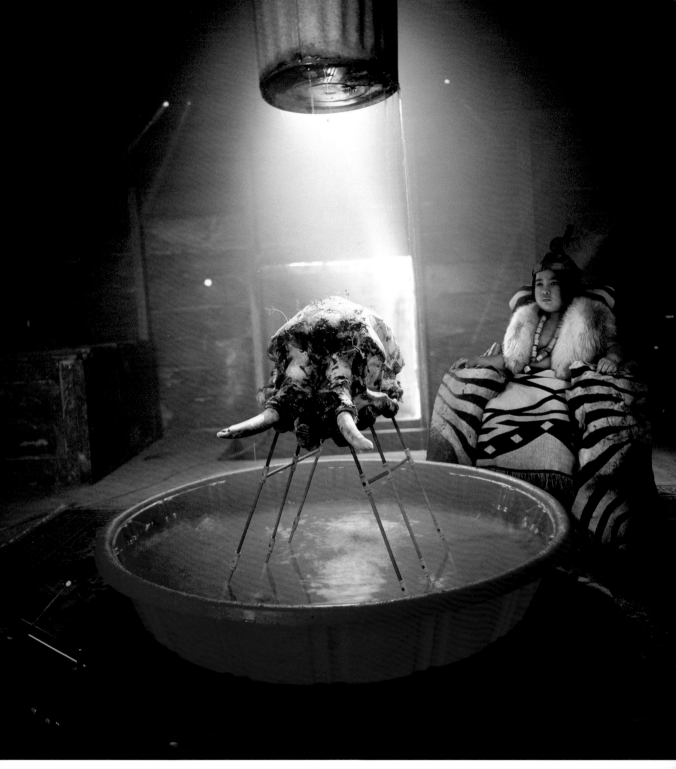

SIMEN JOHAN. *UNTITLED #100*, 2001. C-PRINT, 44 X 44 INCHES. Courtesy the artist and Yossi Milo Gallery, New York.

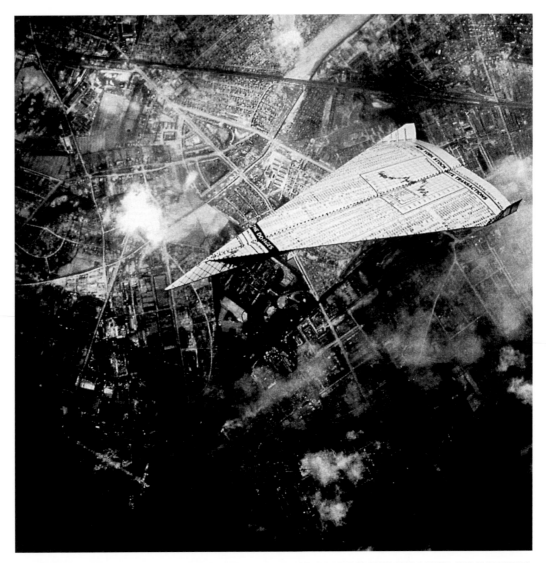

SALLY GRIZZELL LARSON. *NO. 1 (43° N, 3° S)*, FROM THE SERIES FLIGHT, 1999–2001. IRIS PRINT ON PAPER FROM A DIGITAL FILE, 24 X 24 INCHES.
Courtesy the artist.

the expectations of the viewer. Johan sums up perfectly the sensations evoked by these landscapes of memory: like dreams that we fail to remember when we wake, they appear vaguely familiar and produce disquieting associations. His later images, such as *Untitled #100*, are more obviously staged tableaux, photographed in many exposures and combined in the computer. Its subjects are children, intensely engaged in performing complicated rituals or showing the viewer the results of these fantastic events. The rituals reveal the rich fantasy lives of children, a reminder that digital artists are able to create imaginary landscapes limited only by their imaginations.

Nostalgia is also an important concern for Sally Grizzell Larson. She writes: "There is something deeply embedded in our consciousness about flight, of being airborne high above, where boundaries become arbitrary and meaningless." Her images of sinister paper airplanes in dreamlike flight, like Weiss's landscapes, evoke in the viewer a slight sense of uneasiness: What is powering these planes? Where are they going? Will they not simply crash to the ground?

Tom Chambers's constructions recall a time removed from the everyday, a mythic or dream time. Meyer and Lopez use evocative imagery to shift perceptions about real histories, but Chambers is speaking about more general themes of innocence and memory. He tries to "illustrate photographically the fleeting moods that can be seen by a traditional camera or the naked eye."

Not all digital dreamscapes are so far removed from the realm of common experience as these, however. Thanks to the computer, everyday scenes can be subtly transformed. In Mary Frey's *In her Bedroom*, from the series Telling Stories, a seemingly ordinary mirror in a homely room becomes a window to an earlier time. Frey describes the series as revealing "truthful fictions and fictional truths," and indeed the image is as full of narrative possibilities as the word "fiction" implies.

In Florian Maier-Aichen's *Untitled (Mount Wilson)*, the artist has used a long exposure and digital tools to obscure the identifying details of the city, creating a ghostly, otherworldly cityscape. It recalls the dystopian Los Angeles of the 1982 film *Blade Runner,* a film that set the visual tone for many artists of the time.

Unlike avatars, whose existence is all surface, the work of the artists in this section suggests something beneath the surface, an undercurrent of something marvelous, something unseen, something enchanted. They have used digital tools to reveal the hidden truths of everyday existence, to suggest that the stories of our lives may be richer than we would ordinarily think. As Bruce Nauman once wrote in a neon sculpture: "The true artist helps the world by revealing mystic truths."

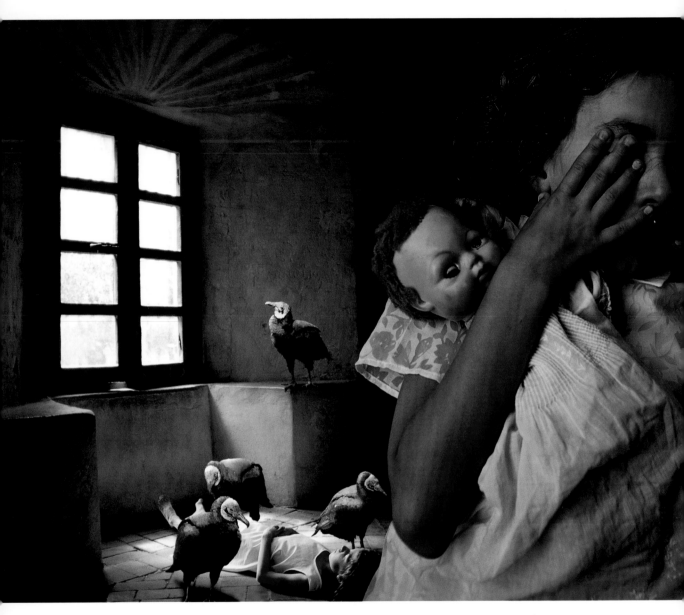

TOM CHAMBERS. *THEY COMFORT*. 2003. ARCHIVAL PIGMENT PRINT ON WATERCOLOR PAPER, 14 X 22 INCHES. Courtesy the artist.

MARY FREY. *IN HER BEDROOM*, FROM THE SERIES TELLING STORIES, 1997. IRIS PRINT. 35 X 47 INCHES. Courtesy the artist.

OVERLEAF:
FLORIAN MAIER-AICHEN. *UNTITLED (MOUNT WILSON)*. 2002. C-PRINT. 63¹/₄ X 81¹/₄ INCHES. Courtesy the artist and Blum and Poe, Los Angeles.

The INDECISIVE Moment

Common sense, augmented by years of experience looking at traditional photographs, tells us that a photograph records a single instant from a single point of view: photography is the act of witness, as the critic Max Kozloff calls it. But since digital photographs are not limited by the same constraints as traditional photographs, today's photographers may combine several instants in a single frame, taken from several points of view. Once, a photographer had to wait passively for the compositional elements of a picture to come together in the camera's viewfinder, in what Cartier-Bresson called the "decisive moment." By allowing the practitioner to create his or her own decisive moment through collage, digital photography has fundamentally changed the way in which time is represented in images. Because digital tools allow the photographer the ability to seamlessly rework the contents of the frame, many photographers work more like still-life artists than the street photographers of the past. Instead of wandering the streets like a hunter tracking prey, they can venture

BARRY FRYDLENDER. *THE FLOOD*, 2003. DIGITAL C-PRINT MOUNTED ON ALUMINUM WITH GALLERY PLEXI, 52 X 92 INCHES. Courtesy Andrea Meislin Gallery, New York.

Barry Frydlender's photographs appear for all intents and purposes to be traditional, even pedestrian, scenes. But they are in fact collages, carefully constructed of photographs Frydlender has gathered over periods of weeks or months.

EVELYN LATTEIER. *UNTITLED.* 2002. DIGITAL PHOTOGRAPH. Courtesy the artist.

out into the world, collect the picture elements they like, and piece them together in the dimroom, just as a still life artist would collect objects to assemble later in the studio. This new digital collage technique has precedents in early European and some non-European painting as well as nineteenth-century landscapes.

Before the development of one-point perspective in the Renaissance, European artists would often portray several events from a story in a single image. In other words, the canvas looked less like a snapshot and more like a time-lapse photograph. A nineteenth-century pioneer of photography, Oscar Gustav Rejlander, famously combined thirty negatives to create his epic *The Two Ways of Life*, while later photographers like Duane Michals used similar techniques to create surreal images in the twentieth century. Today, digital photographers are rediscovering these visual techniques. The artists in this section have manipulated the representations of time and space to create fantasy environments that explore the nature of digital imaging, and our perceptions of the world around us.

Evelyn Latteier used twenty-first-century image-editing software to create a digital montage that brings many instants (or incarnations of a dog) together into a single frame. Like Andreas Gursky, she is thumbing her nose at the constraints of traditional, film-based photography, to create a scene that is familiar and at the same time utterly foreign. Mathieu Bernard-Reymond's work is similar to that of

MATHIEU BERNARD-REYMOND. *SANS TITRE NO. 18,* FROM THE SERIES INTERVALLES. INK-JET PRINT, 19⅝ X 24⅜ INCHES. Comissioned by the Centre national d'Art contemporain, France. Courtesy the artist.

Latteier; he too uses digital technology to compress many instants into a single frame, though his end result is somewhat subtler. While Latteier's image shows a dog seemingly everywhere at once, perhaps reflecting the experience of living with a hyperactive poodle, Bernard-Reymond's is a meditation on the passage of time through a place. He shows a scene as one might observe it over a period of time, as figures move to different places in the scene.

In Jeff Wall's computer-manipulated photograph, *A Sudden Gust of Wind,* a convention from illustration—the depiction of a multiplicity of events in a single frame in spite of the fact that they actually occur in rapid succession—is adapted to the photographic medium. It would be meaningless to say that this photograph represents a specific point in time, or even a specific place, although our visual sensibility tells us so. Beate Gütschow's images (see p. 88) draw on conventions from eighteenth-century painting, especially the notion of the picturesque, a term that literally means "fit to be painted." To create her images, Gütschow painstakingly assembles up to thirty separate photographs taken at different times and locations. Photography in its early days was a hands-on process, and photographers

OVERLEAF:

JEFF WALL. *A SUDDEN GUST OF WIND (AFTER HOKUSAI),* 1993. CIBACHROME TRANSPARENCY IN LIGHTBOX, 90½ X 148½ INCHES. Collection of the Tate Gallery, London. Courtesy the artist and Marian Goodman Gallery, New York.

FLORIAN MAIER-AICHEN. *HOMBERGER BRUECKE*. 2004. C-PRINT. 48 X 60½ INCHES. Courtesy the artist and Blum and Poe, Los Angeles.

accustomed to painting emulsions onto negatives by hand, were also accustomed to assembling images. For instance, nineteenth-century photographic emulsions lacked the tonal range to capture both sky and foreground, so early photographers made two exposures, then made a single print from the two negatives. Gütschow is not interested in reproducing reality in this way, but in enhancing it, of working toward an ideal landscape: "In my work, ideal means not to exclude ugliness, it means to construct reality."

Florian Maier-Aichen's manipulation of the image is simpler than Gütschow's, and more obvious. His *Homberger Bruecke* shows a straightforward photograph of a bridge in which the roadway is twisted as though by a natural disaster, perhaps foreshadowing a future event as well as a metaphor for the ways in which digital technology has shaken the foundations of traditional photography. Jeremy Dawson's series Men in Suits pokes fun at both the practice of street photography, and our love of the espionage genre, by using digital technology to manipulate the time and space of photographs. Because the photographs were shot on 35mm film and then printed on traditional photographic paper, the viewer is uncertain of whether the image is manipulated or not. Dawson prowled the streets of New York City, just as a legion of street photographers had done before him. Unlike those working with analog film,

JEREMY DAWSON. *UNTITLED*, FROM THE SERIES MEN IN SUITS, 1993. GELATIN-SILVER PRINT, 16 X 20 INCHES. Courtesy the artist and the School of Visual Arts MFA Photography and Related Media Department, New York.

Dawson was able to find elements that interested him, photograph them, and digitally combine them to create a scene that is just slightly surreal.

Nancy Davenport's series The Apartments, from which *Bombardment* is taken, shows a number of violent acts—a missile attack on a building, a man jumping from a balcony, an apparent terrorist takeover—set in plain, white, modernist buildings familiar to city-dwellers in the United States. Davenport refers to them as "constructed photographic moments"—a seamless combination of photographs that creates a believable whole. In making the images, she was aware of the tension between collage, where the manipulation of the images—the edges—was traditionally left visible, and photographs, which are thought of as seamless. All images tell stories; her stories reflect the anxieties of our post-9/11 times.

By digitally manipulating his photographs, often inserting his own likeness several times, Anthony Goicolea is able to tell stories that are much like our dreams or childhood memories. They tread the fine line between concrete recollection and the intrusion of fantasy. While adolescence is traditionally seen as the transition from youth to maturity, Goicolea reverses the process, transforming himself back into an adolescent boy through costume and digital manipulation. His photographs allow him to act

NANCY DAVENPORT. *BOMBARDMENT*. FROM THE SERIES THE APARTMENTS. 2001. C-PRINT. 38 X 50 INCHES. Courtesy the artist and Nicole Klagsbrun Gallery, New York.

out incidents from an adolescence that is at once familiar and fantastic. *Pool Pushers* shows an indoor pool populated by some three dozen young men, some sitting by the side, some floating in the pool, while still others stand with nets, seemingly ready to pull the swimmers to safety, or drag their corpses from the water. Here, Goicolea's adolescent boys (incarnations of himself) walk the line between childhood and adulthood, between innocence and sin, between reality and fantasy. The image is impossible, just like our memories.

The work of the artists in this section suggests that we may have to think about photography differently in the twenty-first century than we did in the twentieth, that we may be returning to a nine-teenth-century way of seeing. One hundred years ago, photography was much closer to the manual

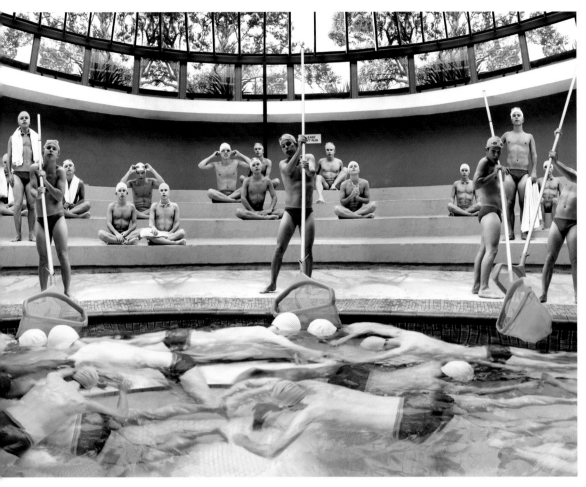

ANTHONY GOICOLEA. *POOL PUSHERS*. 2001. COLOR PHOTOGRAPH. 71 X 100 INCHES. Courtesy the artist and Postmasters Gallery, New York.

labor of painting than the mechanized, clean, and hands-off process that we know to be the film-based photography of the past few decades. Photographers in the nineteenth century did a great deal of physical manipulation of materials. Preparing a glass plate for exposure was a time-consuming and difficult task that required the photographer to manually coat the plate with emulsion. Perhaps for that reason, photographers were much less reluctant to manipulate the contents of their photographs, to cut them up and recombine them, or to work the surface of the print to achieve a desired effect. It was not until the twentieth century that our culture became less reluctant to alter the sacrosanct photograph. Digital tools have rendered that attitude obsolete by making photographs so easy to manipulate. As the saying goes, "when you have a hammer, everything looks like a nail."

Expanding the
BOUNDARIES
of the Self

While the work of many of the photographers shown in this book suggests the nearly limitless potential of the digital tools now available to photographers to manipulate the contents of an image, the everyday user of digital cameras will more likely be struck by two of digital technology's other properties: the ease of creating and distributing images. As with other electronic devices, digital cameras have come down in price, and decreased in size dramatically from their initial introduction in the 1980s, when cameras were bulky and often cost more than ten thousand dollars. Today, consumer-level digital cameras rival film in quality and are making their way into everything from cell phones to eyeglasses. As digital cameras have become nearly universal, integrating themselves into the very fabric of our lives, people use them to record the goings-on of their everyday lives, transforming ephemera into personal narratives. The ability to place images on Web pages has made the Internet into a global exhibition space, displaying everything from personal snapshots to fine art exhibitions to scientific

NATACHA MERRITT. *IMAGE05* (detail). 1999. DIGITAL PHOTOGRAPH. Courtesy the artist.

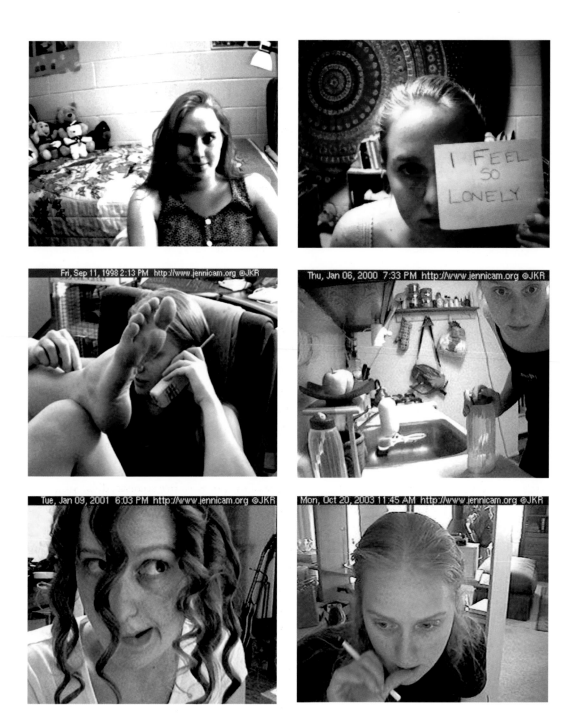

JENNIFER RINGLEY. DIGITAL PHOTOGRAPHS, 1996, 1997, 1998, 2000, and 2003. Courtesy the artist.

Well before the reality-TV craze, Jennifer Ringley made her private life into a public spectacle through her website jennicam.org.

images. As with many other technologies, photography is used widely as a storytelling device. The question is: what are the ways in which digital technology has changed the story?

One pioneer of the new digital storytelling was Jennifer Ringley. Ringley placed a digital camera in her Dickinson College dorm room in 1996 and began nearly a decade of broadcasting her daily life over the Internet. Soon afterward, she founded Jennicam.com, placing several cameras around her apartment and broadcasting images of what was once her private life. While the site occasionally showed images of Ringley in the nude, for the most part viewers were attracted to the intimacy of the site, by her comfort in front of the camera, and by the reassuring banality of her everyday life.

Ringley took advantage of digital media as a means for self-expression and self-exploration, exploiting its unique qualities to open a window into her personal life and to share it with others. She anticipated the rise of so-called "reality TV," television shows that lock a group of people in a house, or strand them on an island, for example, and then broadcast the results. She, too, created situations, placed people in them, and recorded the results. Ringley and those who visited her apartment were acutely aware, though they may not show it, of being observed. As with other work considered in this book, the art in this section straddles the line between truth and artifice.

The genesis of today's Web cam can be found in a computer science lab at Cambridge University in England, where the scientists had a desire for fresh coffee that led them to use their local network to let them know when it was available. While the computer science faculty was spread across several floors of the building, there was but a single coffee machine. Programmers, notoriously reluctant to leave their desks, would often travel great distances within the building only to find that there was no coffee made. To give their colleagues instant information on the availability of coffee, Quentin Stafford-Frasier and Paul Jardetzky trained an unused video camera on the coffeemaker, connected the camera to their network, and wrote software that would take a picture of the pot every few seconds, displaying it on the screens of the computers on the researcher's desks. While the image was only grayscale, this was adequate, noted the researchers, "because so was the coffee."

The Cambridge coffee-cam was built from an expensive frame-grabbing video camera, but soon inexpensive consumer-level cameras became available. These devices, known as Web cams because their primary use is to broadcast images over the World Wide Web, are digital cameras able to capture low-resolution digital images several times per second, just as a traditional movie camera takes many photographs per second. These digital images can be recorded in sequence on a computer and played back like a movie, or broadcast live over the Internet.

Today, there are thousands of such reality cams across the world, broadcasting everything from obvious pornography to the utterly banal (the peeling-paint cam). The early World Wide Web allowed anyone with access to a computer to create what was then called a "home page," a personal site on the Internet. Digital cameras have provided the ability to put images on the Web, to add photographs to these home pages. The surveillance-camera aesthetic of Web cams, along with such phenomena as reality-based TV shows and cameras attached to the noses of guided missiles, has become a part of modern visual culture, influencing everything from fine art to fashion.

For Ringley and others, the Web provides a means to present their images to a broad audience at a low

cost. Since its inception, photography has allowed people to tell stories, from the *cartes de visite* of the nineteenth century, which allowed the burgeoning middle class to show off its newfound wealth, to the snapshot of a grandchild passed around the office in the twentieth century. Digital images on the Internet have created a mass audience for these stories, reaching millions of people across the globe.

Photographers have long used the medium as a means for keeping a personal diary. In the 1960s, photographers such as Larry Clark and Danny Lyon photographed the worlds around them: Clark the sex and drug use of Southwestern American teens, and Lyon the motorcycle gangs of which he was a part. Until very recently, however, photographers have not turned the lens directly on themselves. Cindy Sherman was among the first to do so with her elaborately staged tableaux, wry comments on notions of gender and identity in modern society. Yet no photographer has, until now, been able to combine the documentary nature of Lyons's and Clark's work with the self-portraiture of Sherman. Nan Goldin's groundbreaking work *The Ballad of Sexual Dependency* came close, but her self-portraits were obviously and intentionally staged—shot with the camera on a tripod, or by a friend. Perhaps this is because it is not only physically awkward to turn a traditional camera on one's self, but it is also nearly impossible to see through the viewfinder.

These limitations have been overcome by a new generation of digital cameras. Natacha Merritt, who kept a visual diary of her sexual encounters, which she published in 2000 in the book *Digital Diaries*, had kept a written diary as a teenager, but soon began to use a digital camera in place of the pen. For her, the camera became more than a mere recording device, and in many ways it created the reality she was acting out, so that the act of photography becomes an integral part of the sexual experience. On the digital camera she owned, the "viewfinder" consisted of an LCD screen, or liquid crystal display, on which she could see the photograph before it was taken. The screen could swivel, so that not only could she preview the photograph she was about to take, but she could also turn the camera on herself, using the screen as a mirror in which she could examine and record her own actions. Unlike traditional photographers, she does not need to wait for the film in her camera to be processed to see the image. The act of digital photography is an instantaneous one, one that, like sex itself, provides instant feedback, instant pleasure. Perhaps as important as the ease of creating images in digital media is the inexpensiveness. Every time a photographer presses the shutter of a traditional camera, it costs money. Film must be bought, processed, and printed, each step requiring expenditure of time and material. Digital images require only a small amount of electricity to create. Thus, there is no reason not to press the shutter at a particular time. Every moment of life, no matter how trivial, can be recorded by the digital camera.

After the publication of her book, Merritt moved her work to the Internet, in part because it allowed her to continue her project without the cost of publishing another book, in part because of the creative freedom it allowed her, and in part because it allowed her to make a wider range of images available: "[I] enjoy the freedom of not being in print, because I've noticed that as soon as my work became published [in book form] it was no longer in my control." Another reason is that the site supports her financially: she charges money for "membership" to her site, which allows access to a wider range of images (as with Ringley's site, "guests" see a limited number of images).

The logical extension of Merritt's and Ringley's work is the photo blog, which grew out of the practice of "blogging" (short for "Web log"), posting short pieces of writing on the Web as an online diary. This practice existed in various forms on the Web since its inception, but the availability of software in the early years of the new millennium has made the process accessible to nearly anyone. Early written blogs tended to focus on technology, since those writing them were technically sophisticated. Today, ready-made software allows anyone with a connection to the Internet to create a blog, and their contents range from the musing of adolescent girls, to political commentary, to the writings of a young woman on the lam from her wealthy and powerful family. On her site, isabella v. writes: "On March 2, 2003 at 4:12 pm, I disappeared. My name is isabella v., but it's not. I'm twentysomething and I am an international fugitive." Many people think that isabella v. is a fake, making this particular blog a new genre of fiction.

Blogs are often remarkable for their ability to present unfiltered information immediately—one blog is written by a Baghdad native who posted before, during, and after the U.S invasion of Iraq. The sense of immediacy and ease of creation of text-based blogs applies also to digital cameras, which above all create images quickly and easily. Freed from the constraints of purchasing and developing film, people with digital cameras can easily find themselves with hundreds, if not tens of thousands, of images. The logical thing to do is to post them online (the Web has always been a place for ephemera), rather than to leave them sitting on a hard drive. Photo blogs can offer intimate glimpses into people's lives (often too intimate—some people photograph what they eat for lunch each day) or simply a look at what life is like in a foreign place (Beijing) or a subculture (fashion photographer/club girl).

The relentless pace of miniaturization has placed cameras in everything from ATMs to pens, and recently, into mobile phones, whose quality will soon rival good digital or even film cameras. As with many new technologies, these camera phones were popular initially with gadget freaks, and then with youths, who used them to post photographs of parties on the Web, as they happened, aided by their ability to connect to the Internet with their phones. Eventually, this practice became so popular that it was given the name "moblogging," short for "mobile blogging." In an image-saturated culture accustomed to instantaneous news, moblogging seems a natural activity.

With both photo blogs and moblogs, users have formed themselves into loose-knit communities through Web sites that make it easy for a user to post comments on others' photographs and create a list of their favorite blogs, which makes a visit to these sites a lesson in the labyrinthine nature of the Web. One site, composed of users of a phone called the Hiptop, and calling itself Hiptop Nation, even organized a scavenger hunt, challenging teams of people to find and photograph items on a list—a human skeleton, a cat wearing a costume, a restaurant called Eat, and so on. These activities are a testament to the variety of human activities—from Ringley's seemingly banal Jennicam, to Merritt's lascivious *Digital Diaries*, to the social and artistic intentions of those who create photo blogs and moblogs.

The most salient feature of camera phones is perhaps not their size but their ubiquity. Cell phones are becoming as much a part of people's wardrobes as watches. Since people always have their phone cameras with them, they are more easily able to record the everyday events of their lives. Cell phones have

NATACHA MERRITT. *LIPS PARTED.JPG.* 1999. DIGITAL PHOTOGRAPH. Courtesy the artist.

"All my thoughts and feelings: I used to write them down. As soon as I had a camera, I stopped writing and recorded my thoughts and feelings with photographs. My life has become a bunch of digital photos as opposed to a bunch of written thoughts."

—Natacha Merritt

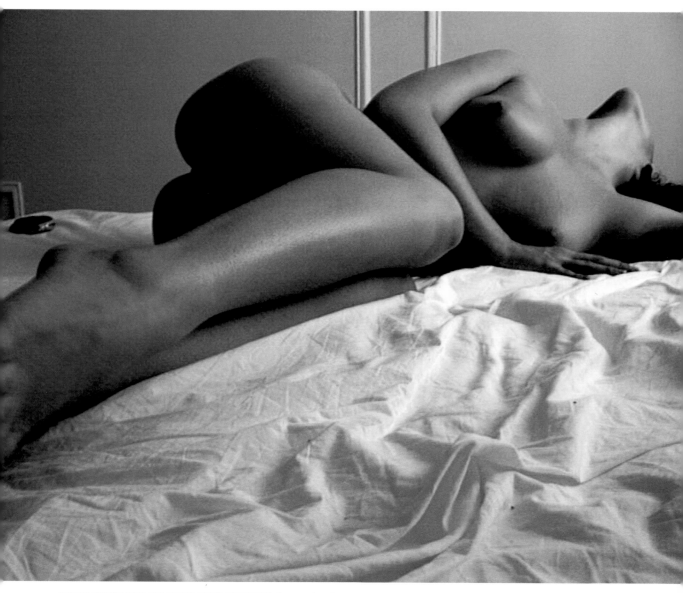

NATACHA MERRITT. *BODY ANGLES*, 1999. DIGITAL PHOTOGRAPH. Courtesy the artist.

been used to photograph everything from grocery store robberies, to celebrities, to candid images of nude people in locker rooms. It was the ability to transmit photographs from cell phones and digital cameras that brought public awareness in 2004 to the torture of Iraqi prisoners by American soldiers at the Abu Ghraib prison. Amateur photographers sent photos to friends and family over the Internet, and they quickly made their way into the international press. Digital technology moves photographs with ease, often without the intent or even the knowledge of their creators.

From the inception of the photographic process in 1839, it has become easier and easier to create photographs. Early images were created in a tedious process that involved evaporating mercury, and whose practice was limited to an intrepid few. As the process became less expensive, difficult, and time-consuming, it grew into the medium we know today, one that has touched the lives of billions of people across the globe, used by everyone from scientists to tourists, from artists to insurance claims adjusters. It is obvious that the ability to change the contents of a photograph has profoundly changed what we think of the process of digital photography. But it is equally the case that un-manipulated digital photographs are changing the nature of photography as well. No longer are photographs objects to be passed around at the office party. Instead, they are created by the thousands, and posted on the Internet to reach the ever-increasing social circles it creates.

IRAQ. 2004. PHOTO BLOG. Courtesy of Faiza Alaraji.

"Under the colored umbrella, there is an American soldier with his machine gun." He wrote: "I want to go home" on the wall behind him.

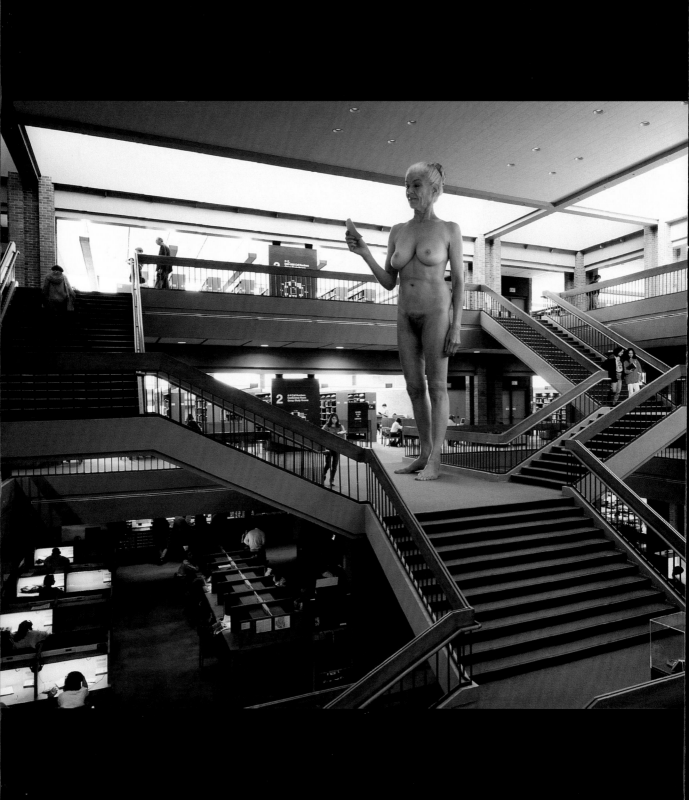

CONCLUSION

Photography has always been a medium whose use and whose reception has been inseparable from the process through which it forms images. Even small changes in the photographic process have created profound changes. So, as digital technology has shaken the very foundation of photographic practice, it is clear that photography will change into something quite unlike what it used to be. The artists and scientists in this book have used the computer to investigate a wide variety of subjects, to explore human identity, to glimpse sub-atomic particles and examine the reaches of outer space in a previously unimagined way. They have even pushed the boundaries of what we consider to be photography. And yet, none of these inquiries are new; they were not created by the technology of digital photography, but are simply part of our ongoing quest as human beings to understand ourselves and our place in the universe. It is all too easy, with any new development, to fall into technological determinism, to say that the technology itself will determine our use of and relation to it. Yet, the artists in this book have demonstrated that for them, digital photography is no more than a means to an end, a medium through which to transmit their ideas.

JEFF WALL. *THE GIANT*. 1992. CIBACHROME TRANSPARENCY IN LIGHTBOX. 19$\frac{1}{2}$ X 23 X 4$\frac{3}{4}$ INCHES. Courtesy the artist and Marian Goodman Gallery, New York.

A Brief History of an Idea:

Fax Machines, Halftones, Video Cameras, and Computers

The development of technology is rarely straightforward. Any invention emerges from a complicated web of relations among various technologies and the culture that produced it. Even something as simple as the paper clip owes its existence to many factors, not only to new developments in steel and paper manufacture, but also to the demands for organizing the increasing quantity of paperwork generated by the nineteenth-century office. We say that Johannes Gutenberg "invented" printing around 1450, but it might be more accurate to say that he brilliantly combined a number of existing technologies, including movable type, the screw press, oil-based ink, and papermaking, to print his famous Bible, at a time when the great demand for the written word could not be satisfied with hand-copied manuscripts. Similarly, digital photography did not simply materialize in the last quarter of the twentieth century. Rather, it combined inventions and techniques developed, in fits and starts, over the better part of a hundred and fifty years to store, process, and transmit information and images more efficiently. These developments were propelled by an

RUSSELL A. KIRSCH AND ASSOCIATES. *UNTITLED*. 1957. DIGITAL FILE. Courtesy Bureau National of Standards.

In 1957, Russell A. Kirsch and his colleagues at the National Bureau of Standards constructed an apparatus which scanned a photograph to create the first digital image.

increasing appetite for visual images in the culture at large. The technologies that led to digital photography were, for the most part, communications technologies—the fax, the telegraph—since visual-imaging technology is often tied to the desire to communicate. The earliest digital images, however, actually preceded the growth of electronic communications, arising instead out of the imperatives of early industrial production at the end of the eighteenth century—in particular, the need to satisfy demand for patterned, woven cloth in France.

At the Paris Industrial Exhibition of 1801, Joseph Marie Jacquard demonstrated an automated loom whose action was controlled by punch cards: as the cards moved through the mechanism, they triggered hooks that wove threads into fabric. Information was stored on the cards digitally, with a bit of information represented by a hole or the absence of one. As long as the cards and the loom remained intact, patterns could be stored and woven over and over again, without the presence of the person who created them. In addition to patterns, Jacquard used the loom to weave his own portrait in silk. The "file" that contained this portrait was stored on thousands of cards. Like any digital file, the pattern of holes on the cards bore no resemblance to an image of Jacquard until it was processed by a device capable of translating the information into physical form. In this sense it was a latent image, one that stored human intention as digital information, and so a direct ancestor of today's digital photographs. It was not long before this concept was applied to technologies that allowed people to communicate over distances. By the 1820s, railroad cars moved at previously unheard-of speeds in networks that expanded across Europe and the United States. In 1830, the Sirius crossed the Atlantic Ocean under steam power, traveling from London to New York in a record eleven days. People traveling by train and steamship expected to be able to keep in touch with those they left behind. This was but one of the many forces that gave rise to the telegraph and the fax; others likely included the increasing amount of business done at a distance and, of course, developments in electronics.

In 1837, two years before the announcements by Louis Jacques Mandé Daguerre and William Henry Fox Talbot of successful photographic technologies, the noted American painter Samuel F. B. Morse patented his telegraph, sparked by a discussion with a fellow passenger returning by ship from Europe, where Morse had been trying to sell his paintings. Upon hearing of experiments in electricity, he is said to have exclaimed, "if this be so then intelligence can be made visible in any part of the circuit." Morse invented a system that translated messages into a quasi-binary language that came to be called Morse Code, which could then be transmitted over electric wires in the form of bursts of current. The code consisted of combinations of dots (short bursts of current) and dashes (long bursts) that stood for letters and numbers. (The system wasn't fully binary, because it also employed pauses between the bursts of current that contributed to the meaning of a message.) Morse Code, an information compression and decompression scheme developed for use in rudimentary communication networks, was so successful that it remained in wide use for more than one hundred and fifty years.

Facsimile (fax) transmission technology developed out of the idea that telegraphy could be used to transmit text or images. In 1843, Scottish inventor Alexander Bain patented the recording telegraph, the earliest fax machine. Bain combined elements of his electric clock and other technologies to build a device that would transmit text over great distances. It consisted of two machines connected

by telegraph wire, synchronized by pendulums and powered by batteries. In traditional printing, individual letters, cast from lead, are put into a printing press where they are coated with ink and pressed onto paper. Bain's system used the same metal type, but eliminated the need for direct contact between the type and the paper through an ingenious electrochemical process. The sender would compose the message out of type, as if for a press. Then, the sending machine would drag a stylus over the raised letters, generating electric current as it touched them. In the receiving machine, a similar stylus was in continuous contact with specially prepared paper. Bain knew that if he soaked paper in potassium ferrocyanide, it would blacken as electrical current passed through it. In this way the shape of a letter on one end of the system would be converted into an electrical signal and then reconstituted on the other end. The image would pass from physical to electrical then back to physical again.

A fax system, called the Pantelegraph, that did not rely on cast-metal type, and so could transmit rudimentary images, was developed by Giovanni Caselli in 1865. With the Pantelegraph, the sender would draw or write the message by scraping insulating ink from a metal cylinder. A pendulum mechanism would drag a stylus over the image. When the pendulum mechanism came in contact with the insulating material, no electric signal would be sent, but when there was no insulating material and the stylus came in contact with the metal cylinder, a circuit was completed and the signal would cause the stylus on the receiving machine to make a mark. As with Bain's machine, synchronization was terribly important; if the timing were off, the stylus on the receiving machine would make a mark in the wrong place and the image would be distorted. Both the sending and receiving machine had pendulums that controlled the rate of the cylinders' rotation.

Early fax technologies mark the first time that the image had come loose from its physical moorings and been reduced to an electric signal. Visual information could now be sent instantly across vast distances. Unlike Jacquard's portrait, however, which was stored on cards, the information that composed the early faxes was fleeting, in existence for the brief period of transmission between sender and receiver. The sending machine blindly sent the signal and the receiver blindly received it, since these early systems had no capacity to process or store images. Yet the concept of breaking down an image at one end and reconstructing it at the other has been used to this day to scan and transmit photographic images. Later machines would simply chop the analog signal into discrete "bits" that could be digitized and stored.

Technology to "digitize" images is as old as printing itself. While most handmade images have tonal gradations and hence consist of hundreds or thousands of different "colors," a printing press can only lay down one color at a time. (This remains true even for color printing: a color press lays down separate colors—usually four—that mix optically, giving the illusion of a range of colors.) This worked well for type, but not at all for reproducing a drawn or painted image's subtle range of tones. Throughout the history of printing, since the fifteenth century, craftsmen struggled to develop techniques to mimic the tonal areas of drawings and paintings, using black ink on white paper. Just as every piece of data that passes through a computer can be broken down into a binary code of ones and zeros, so every monochromatic printed image is created from black and white without any intermediate tones. The earliest woodcutters were satisfied to render the outlines of things, without attempting the shading that

indicates volume. Their successors developed highly sophisticated systems of laying down lines to indicate continuous tones. They discovered that they could fool the eye into seeing tones of gray shading, where there was only black and white, by controlling the thickness, density, and direction of lines and dots. For five centuries, from the fifteenth to the nineteenth, European artists and craftsmen were trained in the exacting art of making prints that used a constantly evolving syntax of lines to express continuous tones.

The invention of photography eventually rendered this tradition obsolete for most practical purposes, but to the printing profession, photographs presented the same problem as had handmade images: how to render continuous tones in the binary language of black (ink) and white (paper). Up until the development of the halftone printing process, photographs were printed as line drawings carved from wood blocks for use in the many newspapers and magazines of the nineteenth century. In about 1860, an English wood-engraver named Thomas Bolton had the idea of sensitizing a wood block so that a photograph could be printed on its surface, as a guide for the engraver to follow by hand carving. Wood engravings would become the predominant means of reproducing photographs in newspapers and books until the turn of the twentieth century. In an age bewitched by science and technology, however, it was obvious that the hand carving of photographs on wood blocks was but a temporary solution. Not only were they expensive and time consuming to create, but they also introduced an element of human subjectivity into the rendition of a photograph that seemed to violate the very essence of the medium. Most important, they didn't even look like photographs. Ultimately, the development of photomechanical reproduction relied on the core insight that made all graphic printing techniques possible: that a network of black lines or dots in varying density can create an illusion of changing tonality even though their color doesn't change. The challenge was to push their scale below the threshold of human vision, so that the lines or dots would disappear but the visual impression of a continuously changing tone would remain. The technology that promised a solution was called aquatinting, and seems to have evolved in late-eighteenth-century Paris. In an aquatint, tiny white dots of irregular shape are surrounded by ink, the balance between them creating the impression of changing tone.

It was pioneer photographer William Henry Fox Talbot who perceived in the aquatint's dots the eventual solution to the problem of photomechanical reproduction. He saw that if a fine grid was superimposed over a photograph, each square in the grid would be filled with a different tone, depending upon how dark or light the image was in that particular portion of it. On a printing plate, each tonal square could be represented by a different-sized dot of ink: a larger dot if the tone was dark and a smaller one if the tone was light. When the plate was printed, the eye wouldn't perceive the individual dots but would blend them together into areas of tone. In 1852, Talbot patented a system to do this, using a photosensitive metal plate exposed to both a screen (he proposed both a textile and a glass sheet with lines ruled in it) and a photographic negative, and then etched in acid so that the resulting dots became pits in the surface to hold ink. Here was the first printing plate for an image that was photomechanically generated with no handwork. In essence, Talbot had invented halftone printing, which continues to be the primary technique for reproducing all images in ink today. His

technique had to go through many modifications in the next fifty years—not least, it needed to be converted to a relief rather than an intaglio method, since the plates would be used in conjunction with type—before being perfected by the end of the nineteenth century, when the mass production of the photographic image came to the printed page.

The concept of laying a grid over an image to break it up into dots was seminal in the development of the modern digital image, which consists of a sequence of solidly toned squares below the threshold of vision that resolves itself into the continuous tones of an image when viewed at normal resolution. In the case of a halftone, the grid is necessary because a range of tones must be achieved with a single ink whose color cannot be varied; in a digital image, the grid is necessary because it divides the image into separate tones that can each be expressed in binary code. Of course, while the halftone image suggests a path to digitization, it is not a digital image. The development of a true bitmapped image, one that was represented entirely by number, would have to wait another thirty years.

Meanwhile, developments in fax technology continued, building on advances in electrical engineering at the end of the nineteenth century. In the late 1860s, Willoughby Smith noted that the electrical resistance of the element selenium changed as it was exposed to light, and investigators began to look for applications that would take advantage of this exciting observation. This was the first recognition of the photoelectric effect, which Albert Einstein would later describe as the conversion of photons (light) into electrons (electricity). Various inventors, such as Constantin Senlecq and George R. Carey, proposed systems that would utilize selenium to transmit still images over wires. But it was Arthur Korn who, in 1902, developed the first optical fax in Germany, using the photoelectric effect to convert photographs into electric signals that could be carried over wires. Korn's device was similar in principle to Caselli's Pantelegraph: the image was read off a rotating drum, translated into an electric signal, sent across a wire, and reconstructed on a rotating drum at the other end of the wire. As in the earlier fax machines, the image was read line by line.

But where Caselli's machine required physical contact between the stylus and the image, Korn's used optical technology, allowing it to transmit actual photographs. Korn's system consisted of two drums, rotating in sync, one with a photograph wrapped around it (the sending machine) and one fitted with a blank piece of photographic film (the receiving machine). As the sending drum rotated, a light shone through the photograph onto a selenium cell, which would send an electric signal based on whether or not the photograph was dark or light in that spot. This electric signal would cause a shutter to open in the receiving machine, allowing light to fall on the film, which could then be developed into a photograph.

In 1906, the system was put into regular use in Germany, and by 1920, the first digitally encoded images were being sent across the Atlantic Ocean by cable using the Bartlane system (named after Harry G. Bartholomew and Maynard D. McFarlane) which introduced the grid of the halftone system to the fax. Images were first converted into a traditional halftone grid, and then the size of each dot of the grid was assigned a discrete numerical value. These numbers were sent via telegraph to a printer that would reassemble the image by printing it using a special typeface resembling a traditional halftone screen. Initially, each pixel could be assigned only one of five numerical values, and thus only

five shades of gray could be represented. Improvements by 1929 allowed for the representation of fifteen shades.

By the 1930s, transmission of photographs by digital fax was widespread, with many major companies involved, including the Associated Press, AT&T, RCA, Western Union, and the *New York Times*. News organizations developed not only machines but also networks to distribute photographs to the plethora of magazines and newspapers that wanted them across the United States. While the digital fax possessed many of the features of modern digital photography—it converted images into electronic signals and transmitted them, breaking them down into units that fit into a grid and could be expressed numerically—it was missing the vital elements of image processing and electric storage. The amount of data needed to store or process an image was simply too large for the computers of the time. The Associated Press's system of the 1930s was capable of sending an eight-by-ten-inch image at 170 lines per inch, with eight bits per pixel. (This means that each pixel could be described by eight binary digits, allowing $256-2^8$-possible shades of gray.) A single eight-bit image this size would require 2,306,867 binary digits to describe it, an astronomically large number even for computers that would be developed twenty years in the future. The ENIAC (Electronic Numerical Integrator and Computer), state of the art in 1949, used 18,000 vacuum tubes, filled a large room, consumed as much electric power as some small towns, and yet could store only twenty decimal numbers at a time. ENIAC was adequate for calculating gunnery tables, which was its intended purpose, but it was unthinkable that such a machine would be able to store and process images.

It wasn't until the late 1950s that the photograph moved into the realm of the circuit. In 1957, Russell A. Kirsch and his colleagues at the National Bureau of Standards converted a photograph into a grid and then fed it into a digital computer. By this time, computers had memories that could barely hold sufficient information to encode an image and were capable of processing information at a reasonable speed. The computer that Kirsch and his colleagues used was the SEAC (Standards Eastern Automatic Computer), the first digital computer that could store information electronically instead of on punched cards or on tape. It was several years old at the time, but readily accessible to Kirsch, who was interested in automating the input of pictorial information into the computer. Within the memory of the computer, Kirsch's team created a virtual space for the image: a string of 30,976 binary digits that would represent a 44-by-44-centimeter black-and-white photograph. An imaginary grid of 176-by-176 squares was laid over the photograph, and based on the tone of the photograph in any square, a binary number—zero or one—would be assigned to it in the computer's memory. (As in Korn's fax machine, the resulting image would be one bit deep.) This zero or one would be used to direct an output device to represent that pixel as either black or white.

Scanning was accomplished through a custom-designed input device that physically resembled Korn's and earlier faxes, but with a few important improvements. It had a rotating drum onto which the photograph was affixed, a light that shone onto the photograph, and a sensor that measured the reflected light. As the drum rotated, a strobe light was reflected off the surface of the photograph onto a photomultiplier tube, or PMT. PMTs, used in astronomy since the 1930s, are vacuum tubes that, like the selenium sensors in early faxes, convert photons into electrons. The PMT would emit an analog

electric current equivalent to the amount of light that hit it, and a digitizer converted the current into a zero or a one. This binary digit would then be added to the memory of the SEAC, filling the grid square by square. The strobe light flashed each time the drum passed through 0.25 mm of rotation. After the drum went through one full revolution, the light would move over 0.25 mm to make another pass. In this way, the image was "unraveled" into a consecutive line of 0.25 mm squares, and each of the squares was assigned a number. Once the scanner had passed over the entire image and each of the 30,976 squares of the grid had been assigned a zero or a one, the scanning process was complete. After the image had been converted into zeros and ones, it needed to be displayed in some way. Cathode-ray tube (CRT) monitors, such as those hooked up to most computers today, were not in widespread use: the SEAC used a device that resembled a typewriter to display the results of its programs. Simply printing out the 30,976 binary digits on a piece of paper and using them to fill a grid by hand was one possibility, although an extremely time-consuming one. Instead, Kirsch and his colleagues connected the SEAC to an oscilloscope through an analog output device. All they had to do was write a program that would display a spot on the oscilloscope, a specialized type of CRT used to test electronic equipment, in a location corresponding to the binary digit in the computer's memory. The resulting image had all the hallmarks of a modern digital photograph: it was binary, digital, electric, bitmapped, and stored. First, it was scanned and converted into zeros and ones. Then the computer stored the image as a sequence of digits in its memory. Finally, it was reinterpreted as an image on a screen. There were several important differences from a fax. The image was not made back into a physical object, it was shown only on a screen. Since the image was stored in the computer's memory, it could be sent to any of a number of output devices, or even to another computer, and could be duplicated endlessly. Furthermore, since the image was now a computer file, it could theoretically be processed (that is, manipulated) electronically, a job that had previously been the purview of human beings. Kirsch, of course, could not process his image because image-processing software had not yet been invented.

In fact, the impetus for the construction of the scanner was to provide data for the field of image processing, which was in a formative state in the late 1950s. Kirsch and his colleagues' 1958 paper described a few suggested uses for image processing, among them the creation of software to extract contour data from stereo aerial photographs. It was only a matter of time before computers would be enlisted in the quest to extract data from images acquired under less-than-ideal conditions, a task that even professionals with highly trained eyes found taxing and imprecise. Obviously, a computer would be able to analyze data only if it was available in digital form.

Beginning in 1959, scientists led by Robert Nathan at the Jet Propulsion Laboratory in Pasadena, California, began to create practical image-processing software. They built a device that could translate the analog video signals being sent back to Earth from NASA's unmanned planetary spacecraft into digital data, and by 1964 they were processing video images of the moon received, from Ranger 7, on an IBM 7094 computer. Unprocessed satellite images were notoriously difficult to decipher. The JPL software could take image data in its raw state and enhance contrast, normalize illumination, remove residual images, and filter out noise acquired by the signal in its transit to Earth.

In 1969, two researchers at Bell Laboratories, Willard Boyle and George Smith, developed the charge-coupled device (CCD), the sensor that would make digital photography possible. A CCD is an array of light-sensitive silicon elements known as pixels. (In fact, the word "pixel" has three meanings: first, squares in a bitmap; second, elements in a CCD; and third, phosphors in a computer's CRT monitor. They all refer to small equal-sized units that make up an image.) The action of photons on the surface of the silicon causes it to release electrons in direct proportion to the amount of light received, generating an electric current. CCDs proved sensitive not only to visible light, but also to a broad band of the electromagnetic spectrum from infrared all the way up to X-rays, which made them particularly useful in astronomy. In 1975, video cameras began to use CCDs, which had improved to the point where they could be used to generate broadcast-quality images via analog signals. But CCDs could also be used to produce bitmaps, with each pixel in the array producing an electric signal coded digitally. Consumer-level motion video cameras began to appear in the 1980s, and with them came still video cameras, devices that would capture still images electronically and store them on floppy disks for transfer to computers or display on television screens. Canon announced its MAVICA (magnetic video camera) in 1981. Picture information was encoded in analog video format. The camera could be attached directly to a television set for display, but since the image was stored in analog form, it needed a special adapter to be fed into the computer. The images were fairly low quality and could not compete with traditional film cameras, which were considerably less expensive and delivered a higher-quality image. And so the MAVICA and other analog still video cameras never really caught on. Adequate consumer-level digital cameras would have to wait nearly twenty years.

Meanwhile, with the invention and refinement of the microprocessor in the 1970s, the cost of the computer-processing power and memory needed to process large images began its long descent to today's levels. By the mid-1980s, photographic-quality image-processing systems, made possible by the growth in computer power, began to appear, including Hell GmbH's Chromacom, Quantel's Paintbox, and Scitex's Response System. Scitex had earlier been in the business of manufacturing systems to control the manufacture of textiles (a curious parallel to Jacquard's loom), its name a contraction of science and textile. The Response System was tremendously expensive, costing more than a million dollars, and marketed primarily to printers and other businesses that prepared images to be printed in ink (called "prepress" work). Photographs or negatives were digitized with a drum scanner. The Scitex operator could then manipulate the images with a computer and output offset film in which the dots were placed by computer-controlled laser. Computer imaging had finally attained the level of photographic quality, and the Response System was used in actual photographic workflows.

In 1985, Deborah Feingold photographed Don Johnson and Philip Michael Thomas, stars of the television show *Miami Vice*, for the cover of *Rolling Stone* magazine using a traditional film camera. In the original photograph, Johnson is wearing a pistol in a shoulder holster. After the shoot, the editors decided that Johnson should appear unarmed. Instead of restaging the shoot, they turned to the Scitex system to retouch the photograph. A few years earlier, an artist would have physically manipulated the photograph by choosing a paint color close to that of Johnson's shirt, and painting over the offending areas with an airbrush. With the Scitex system, the photograph was no longer physical,

and retouching involved not "touching" the photograph but instead changing numbers in a digital image. The Scitex operator used the computer to "clone" areas of Johnson's shirt: pixels from one area of the image were duplicated in another. The Scitex Response System was a tremendously versatile—if costly—tool that could do anything a darkroom technician or retoucher could do, and more.

The Scitex Response System was one of a new crop of electronic tools available to prepress workers, which were installed in newspapers and other organizations that could afford the high prices of these systems. Many of them allowed graphics professionals to lay out newspaper pages electronically, but they were still too expensive to be marketed to the everyday consumer. These systems consisted of a combination of hardware—the physical apparatus that did the scanning, processing, and final output—and software, the program, or set of instructions to the hardware. Most of the companies that developed these systems, from this point on, would choose to focus on one or the other. It was probably this split of the computer-imaging industry into hardware and software companies that radically lowered prices and brought the cost of digital prepress and digital photography into the reach of the everyday consumer. In 1982, *Time* magazine named the personal computer the Man of the Year, and by the mid-1980s, desktop computers had become powerful enough to run graphics programs. The Apple Macintosh computer had been introduced in 1984 but sales languished, as people seemed to prefer IBM's personal computers, even though they were more difficult to use. This was because the Macintosh lacked a "killer app," a software program so irresistible that people would run out to buy the computer just to use that program.

For the original Apple II computers, that program had been Visicalc, a two-dimensional calculator that allowed users to perform complicated calculations on data in a table, a forerunner of today's spreadsheets. For the Macintosh, the killer app was Aldus Pagemaker, introduced in 1985, which created the field of desktop publishing. For an investment of a few thousand dollars, anybody could buy a computer, software, and the newly developed LaserWriter printer, and use them to produce page layouts ready to be sent to the printing press. In effect, anyone could publish his or her own newspaper. Highly sophisticated image-processing software for personal computers followed swiftly. In 1987, a PhD student in computer science at the University of Michigan, named Thomas Knoll, began to write routines for his Apple Mac to expand its image-processing capacity. These caught the attention of his brother John, who worked at Industrial Light & Magic, an up-and-coming special effects studio north of San Francisco founded by George Lucas, where he had seen similar processing tools used for the high-end Pixar Image Computer. Together, they created a program they called Display, which they improved and renamed ImagePro in early 1988, when they began to look for a company to distribute it. In February of 1990, it was released by Adobe as Photoshop 1.0. Photoshop, and other similar software applications that appeared around the same time, placed increasingly powerful photographic correction and manipulation tools in the hands of anyone with a reasonably powerful desktop computer, from the professional photographer to the snapshooter.

Recent advances in sensor technology promise to produce digital cameras with lower costs and superior resolution to photographic film. The first all-digital cameras began to appear in the early 1990s, as Kodak and Nikon teamed up to produce digital backs for traditional cameras. These backs

would put a CCD where the film had once been, so that the front half of the camera, which contained the lens and shutter, would focus light onto a CCD rather than on traditional film. In addition to these hybrid cameras, consumer-level cameras began to appear as well. The initial cameras were, like still video cameras, fairly low quality. This was, for the most part, due to the expense of CCDs.

In order to capture a high-quality image—that is, one with a large number of pixels—a large CCD array was required. It was not until mid-2000 that cameras began to appear that could approach the quality of film at a price consumers could afford. They were sold in consumer electronics stores alongside inexpensive personal computers and photo-manipulating software. In the late 1990s, cameras using CMOS-based (for Complementary Metal Oxide Semiconductor) sensors that are considerably cheaper than CCDs also began to be available. In September 2000, the digital imaging corporation Foveon announced production of a CMOS-based image sensor that, when combined with superior optics, could produce remarkably sharp photographic prints at sizes up to ninety-by-ninety inches, easily outstripping the capabilities of almost all traditional cameras. It is possible that a child born in the year 2000 will grow up with no experience of film cameras, just as a child born in the 1990s has no experience with vinyl albums.

It is worth noting that while the prehistory of digital photography stretches back to the early nineteenth century, it has existed as a practical technology for only about a decade. It is, for all intents and purposes, a new medium. This pattern is mirrored by most of the photographs in this book. Many embody ideas and artistic techniques that have been part of our culture for decades. None could have been created in this medium until the very recent past.

While it is difficult to speculate about the future of any technology, one thing is clear about digital photography: it will follow the same meteoric trajectory as other computer-based technology. In 1965, Gordon Moore, the cofounder of Intel, observed that the number of transistors on a chip—in essence its computing power—would double roughly every year and a half. The practical outcome of what has been termed Moore's Law is that computers have become more powerful and less expensive as time goes on.

Since the sensor in a digital camera is in essence a computer chip, advances in chip design increase the efficiency of digital cameras, allowing them to capture more detail, and to be produced for less money. In the early 1990s, professional digital cameras appeared that were able to rival the detail of film, but were very difficult to use, and cost as much as some automobiles. By 2003, digital cameras of the same quality were selling for less than one thousand dollars.

Price and performance are only one element of the progression of computer technology. Computers, which were once massive, hulking contraptions, now fit on our laps or even our wrists. Digital cameras, which require no more than a chip, some circuitry, and a lens, have also shrunk significantly in size. Driven by his desire to share photographs of his newborn daughter, computer pioneer Philippe Kahn developed technology that would allow him to send a digital photograph through a cellular phone. He licensed that technology to Sprint PCS, and the picture phone was born. A few years later, cell phones that could fit in a person's pocket, and cost no more than a hundred dollars, could take photographs of the same quality as digital cameras that cost a thousand dollars only a decade before. By 2003, cell phone cameras were outselling digital cameras. As their price drops, and the quality inevitably increases, it is not unlikely that they will soon rival film in terms of picture quality, at a much, much lower price.

INDEX

ACKNOWLEDGMENTS

I would like to thank Eric Himmel and Céline Moulard at Abrams for their support and guidance, New York University's Scholar in Residence program, Ramapo College of New Jersey, and Charles Traub for his insight. Finally, this book would not have been possible without the artists who generously shared their work.